CREATIVE STAMPING

Rubber stamping projects on paper, fabrics, ceramics, wood and metal

Compiled by
TRACY MARSH

All the rubber stamps illustrated in this book were provided by the companies listed on page 2, from whom the stamps can be obtained. However, there are many similar stamps available and readers can choose their own designs. The projects show how to apply chosen designs on to many different surfaces.

SEARCH PRESS

Stamp shown above: Serene Sun © Hero Arts.

First published in Great Britain 1996 by

SEARCH PRESS LIMITED
Wellwood, North Farm Road
Tunbridge Wells
Kent TN2 3DR

Originally published in Australia 1995 by

TRACY MARSH PUBLICATIONS Pty Ltd
369A Old South Head Road
Bondi NSW 2026 Australia

Publisher: Tracy Marsh
Graphic Designer: Peta Nugent
Stylist: Anne-Marie Unwin
Production Director: Mick Bagnato
Photographer: Adam Bruzzone
Editor: Leonie Draper

The following companies have supplied stamps and accessories for this book and
hold the copyright on same: Hero Arts; Rubber Stampede; Stamp Francisco;
Embossing Arts; Personal Stamp Exchange; Artarama; StampArt; Print Blocks; Art
Stamps Australia; thInking Stamps; Craft Lovers; Stamp World; Cecily Mary Barker.

ISBN 0 85532 827 4

Printed in Spain by Graficas Reunidas S.A, Madrid

Stamp shown above: Pansy © Hero Arts.

CONTENTS

Stamp shown above: Sea shells © Personal Stamp Exchange

INTRODUCTION

In the past, rubber stamps were mainly considered useful as a stationery accessory for businesses or for amusing children. Stamping has now become one of the most popular crafts among adults and children alike. Stamps can be used to great effect on cards, stationery, packaging, clothing and on decorative pieces.

Stamping is loads of fun. It is quick and easy to do and the whole family can join in. This book will show you many ways in which rubber stamps can be used to produce beautifully creative works with little fuss or mess.

There are hundreds of different rubber stamp designs to choose from and many different techniques and products. Multi-coloured stamp pads, glitter glues and embossing powders all give scope to your creative ambitions. Even more diversity is possible in the final appearance of your stamped pieces simply by using different materials, colours and textures as your basic stamping surfaces.

Stamping will provide you with hours of relaxed, creative enjoyment and will result in endless delightful and practical finished pieces.

Rose © Craft Lovers

ABOUT THIS BOOK

Below are some of the pages from this book which have been annotated to show the various types of information and instructions that you can refer to. The tools and materials that you need will be found on pages 6–7 and the basic techniques of stamping are given on pages 8–9.

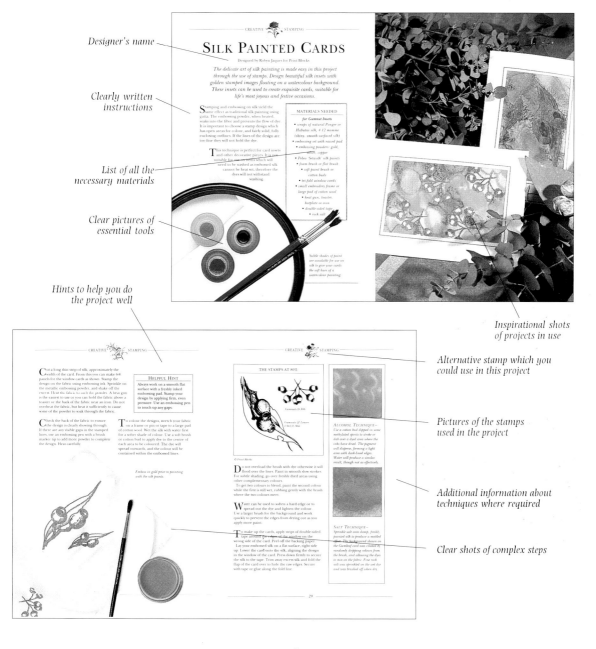

Designer's name

Clearly written instructions

List of all the necessary materials

Clear pictures of essential tools

Hints to help you do the project well

Inspirational shots of projects in use

Alternative stamp which you could use in this project

Pictures of the stamps used in the project

Additional information about techniques where required

Clear shots of complex steps

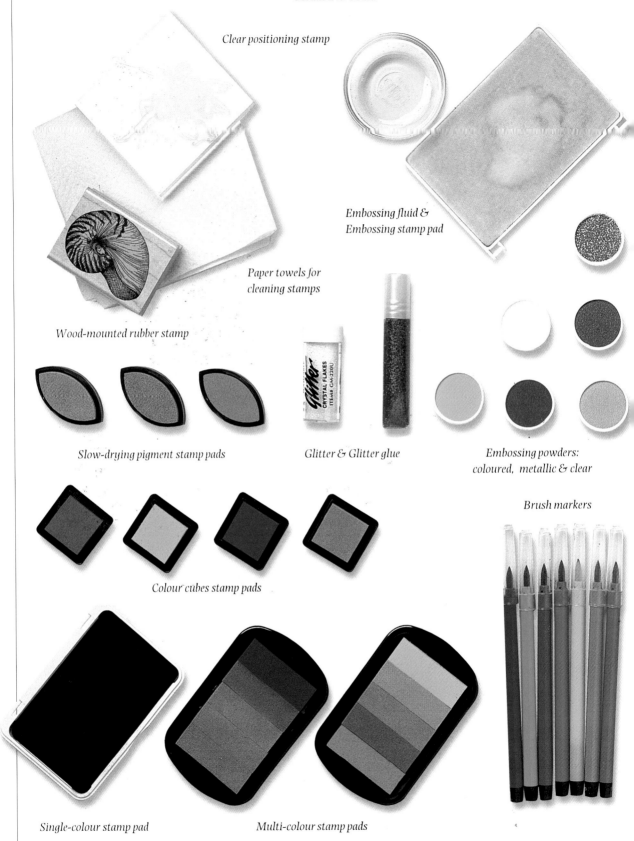

Clear positioning stamp

Embossing fluid &
Embossing stamp pad

Paper towels for
cleaning stamps

Wood-mounted rubber stamp

Slow-drying pigment stamp pads

Glitter & Glitter glue

Embossing powders:
coloured, metallic & clear

Brush markers

Colour cubes stamp pads

Single-colour stamp pad

Multi-colour stamp pads

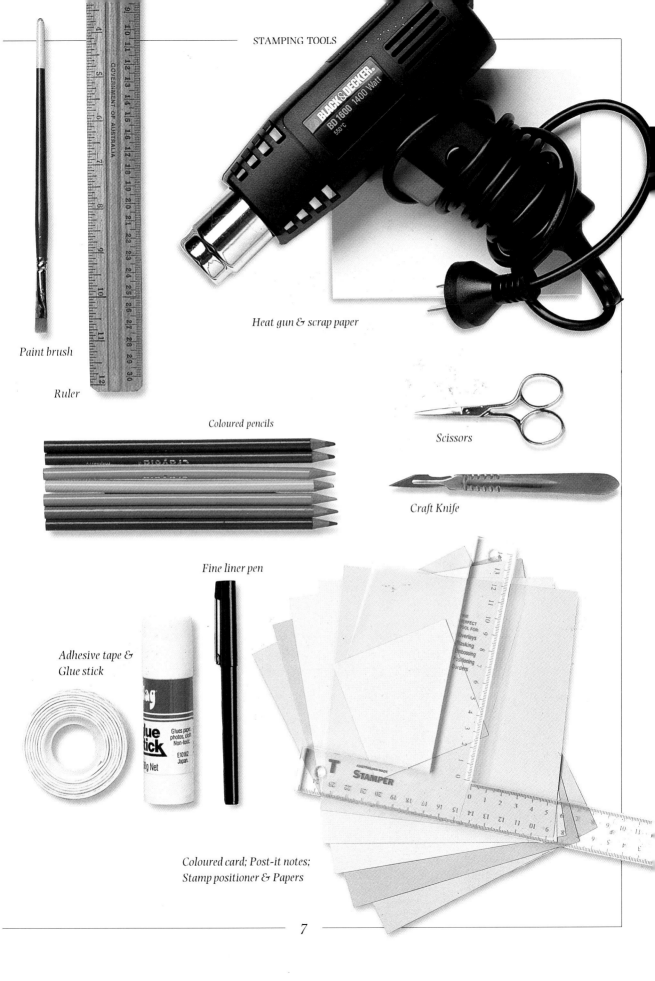

Heat gun & scrap paper

Paint brush

Ruler

Coloured pencils

Scissors

Craft Knife

Fine liner pen

Adhesive tape &
Glue stick

Coloured card; Post-it notes;
Stamp positioner & Papers

CARING FOR YOUR STAMPS

It is important to properly care for your stamps so that they will last well and will continue to provide clear images each time you use them.

STORING STAMPS

Always store your rubber stamps face down in a box with a lid. To easily locate each stamp as your collection grows, stamp each of the rubber stamps that are stored in one box on to a single piece of paper and attach this sheet of paper to the top of the box. Do this for all your stamp storage boxes. Never expose your stamps to heat or sunlight.

CLEANING STAMPS

For a cleaner, sharper stamp image every time, clean your stamps after each stamping. This is especially important when you have done some stamping and are about to start working with a different coloured ink. To clean your stamps, stack at least five sheets of paper towel on a shallow tray or plate and spray them with a cleaning solution such as a window cleaner or with detergent and water. Blot the stamp on the stack of moistened paper towel and then on a dry paper towel.

STORING STAMP PADS

Keep your inked stamp pads in the refrigerator to make them longer lasting. Always store them flat so the ink will stay evenly spread across the stamp pad.

STAMPING TECHNIQUES

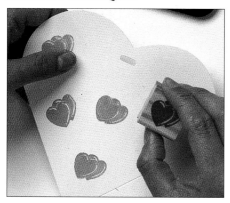

BASIC STAMPING

Press the stamp on to the inked pad, then position it on the project and press firmly with the palm of your hand. Do not rock the stamp or the image will blur. Never move the stamp around on a multi-coloured stamp pad as it will muddy the colours.

MIRROR IMAGES

To produce mirror images of a design, use a plain rubber stamp or a flat pencil eraser. Working quickly, stamp the image on the flat eraser, breathe on it to keep it moist and quickly stamp the mirrored image where required on the project.

EMBOSSING

Stamp the design with an opaque pigment ink pad or with embossing ink. Pour embossing powder or tinsel generously over the wet design. Brush off excess powder and pour it back into its container. Set with a heat gun, toaster, iron or hotplate.

MASKING AND REPEATING

To overlap stamped images, stamp the full image first, then stamp the same image on a Post-it note. Cut out the sticky-backed image and position it exactly over the original image. Stamp the image again so it overlaps both the Post-it note and the project. The second stamped image will look as though it is in the background. Remove the mask.

COLOURING IN & PAINTING STAMPS

After stamping the image, use water-based coloured markers to colour it in. You can also use the marker to paint directly on to the stamp. Always use the lighter coloured markers first. Breathe on the stamp to moisten the ink before stamping.

POSITIONING STAMPS

A stamp positioner helps you to place images exactly. Place the corner of a sheet of tracing paper in the corner of the positioner. Put the stamp in the corner and stamp the image. Move the tracing paper into position on the project. Put the positioner back on the corner of the tracing paper. Remove the paper, ease your inked stamp into the corner of the positioner and stamp the image on the project.

DIE-CUTS & 3-D STAMPING

Stamp the design in the centre of a flat piece of card. Use a craft knife to cut around the top of the design. Fold the card to make a shaped placecard. Add a three-dimensional look by cutting out images and attaching them with foam-backed double-sided tape.

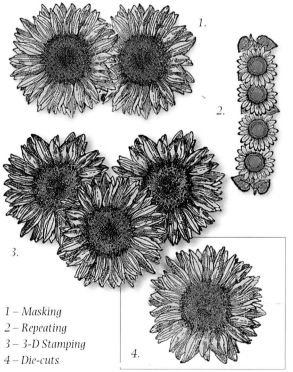

1.

2.

3.

4.

1 – Masking
2 – Repeating
3 – 3-D Stamping
4 – Die-cuts

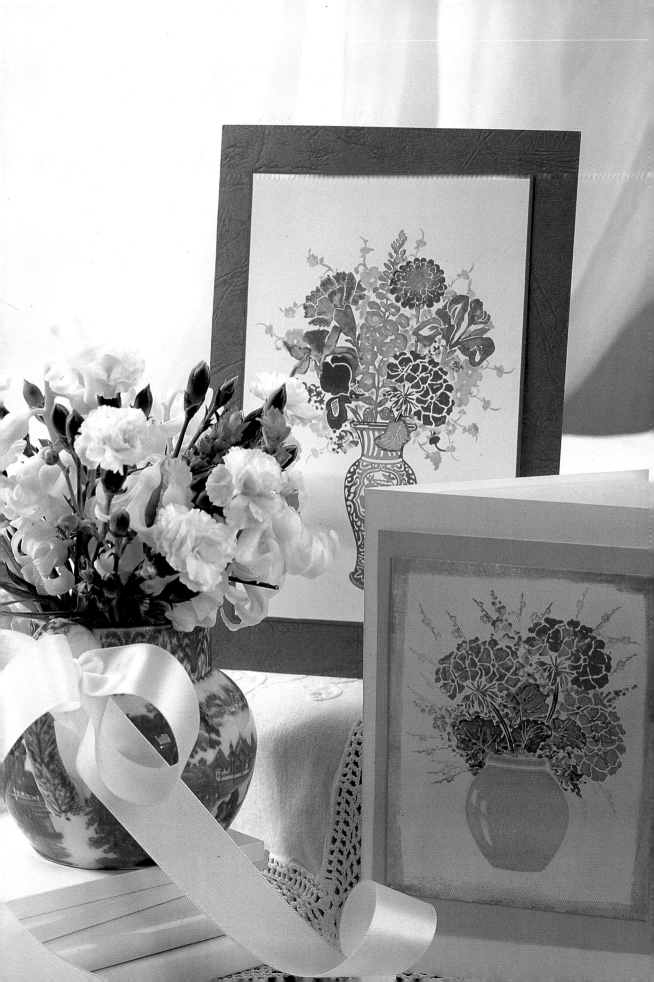

BLOSSOMING CARDS

Designed by Laurie Mein

These four delightful cards, inspired by images of nature, are perfect for any occasion. Using a variety of intricate stamps with pretty pinks, crisp blues and purples, you can create the cards of your desire. From a Ming vase of glorious flowers, to a collection of eye-catching butterflies, these cards are easy to make and the results are truly spectacular.

MATERIALS NEEDED

for Ming Vase Arrangement

- brush markers
 in various colours
- stamp positioner (optional)
- shiny white self-adhesive paper
- tracing paper
- Post-it notes
- mounting tape
- plain shiny white
 gift card
- dark blue backing card
- scissors or craft knife
- cutting mat
- ruler

Colour directly on to the Ming vase stamp with two shades of blue markers. Use the lighter colour first. Breathe on each stamp to moisten the ink and then stamp the image on the front of the shiny white card (see illustration of the finished card on page 13 for positioning). Working on a mat, use scissors or a craft knife to cut out a mask for the Ming vase and stick it in place over the stamped Ming vase.

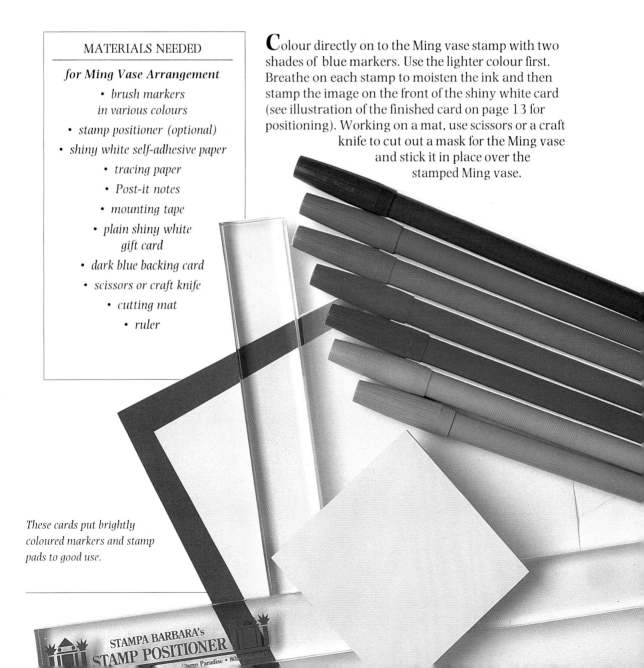

These cards put brightly coloured markers and stamp pads to good use.

STAMPA BARBARA's
STAMP POSITIONER

A stamp positioner is ideal for accurately placing intricate arrangements such as this one. It makes stamped borders a breeze too.

The stamp positioner can now be used for accurate placement of the remaining flowers (see 'Positioning stamps' page 9) or simply refer to the photo of the finished card. As you stamp and mask each flower, be sure to breathe on each stamp to moisten it before stamping. Leave all the masks in place until the entire picture is complete. When you have stamped the full arrangement, remove all masks and, if necessary, touch up the flowers using a marker or a fine brush coloured with ink from a marker.

Next, stamp a separate leaf from the geranium stamp on to the shiny self-adhesive paper, trim around the edge and attach to the edge of the vase. Use a ruler to edge the card with a red marker and mount the card on to the slightly larger blue card with mounting tape.

THE STAMPS REDUCED IN SIZE

Classic iris

Daffodil

Carnation

Geranium

Zinnia

Floral filler

Foxglove

Ming vase

Iris

STAGES FOR STAMPING ARRANGEMENT

It is important to work from lighter colours to darker colours. Leave masking in place over each stamped flower until you have finished.

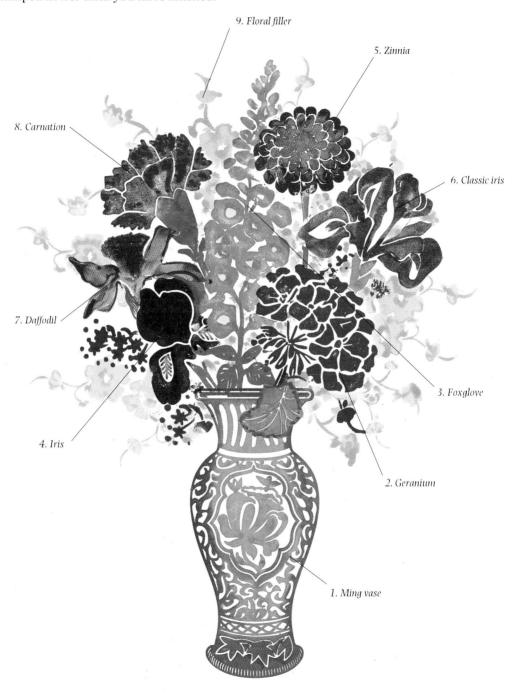

9. *Floral filler*

5. *Zinnia*

8. *Carnation*

6. *Classic iris*

7. *Daffodil*

3. *Foxglove*

4. *Iris*

2. *Geranium*

1. *Ming vase*

THE STAMPS REDUCED IN SIZE

Floral filler

Geranium

Vacant vase

© *Rubber Stampede*

MATERIALS NEEDED

for Pink Geranium Card
- *Brush markers in various colours*
- *stamp positioner (optional)*
- *tracing paper*
- *three-colour inkpad in yellow, green and lilac*
- *embossing powder: white pearl*
- *Post-it notes*
- *plain shiny white gift card*
- *pink backing paper*
- *glue pen*

Ink up the vase stamp using the lilac end of the three-colour inkpad. Hold the stamp, rubber side up, in one hand, and the ink pad, upside down, in the other hand, and tap the lilac ink lightly on to the vase stamp until it is completely inked.

Stamp the vase in position on the front of the shiny white card and emboss with the white pearl powder. Mask the vase with Post-it notes.

Colour the geranium stamp with your choice of brush marker colours (see finished card on page 10) and stamp above the vase, use masks where necessary. The stamp positioner will help you to achieve exact placement. Colour the floral filler stamp with a suitable marker and stamp the filling in around the geraniums.

To create the lilac edging for the card, tap the three-colour inkpad gently around the edge of the card, then emboss with the white pearl powder. Mount on the pink paper and then mount again on shiny white card. Insert pink paper inside.

MATERIALS NEEDED

for Peony Card
- *Brush markers*
- *scissors or craft knife*
- *sea sponge*
- *plain shiny white gift card*
- *gold backing card*
- *foam-backed, double-side tape*
- *double-sided adhesive tape*

Stamp three peony flowers on to the shiny white card referring to the finished card for colours. Be sure to paint right to the edge of each stamp and breathe on the stamp each time to ensure a good image.

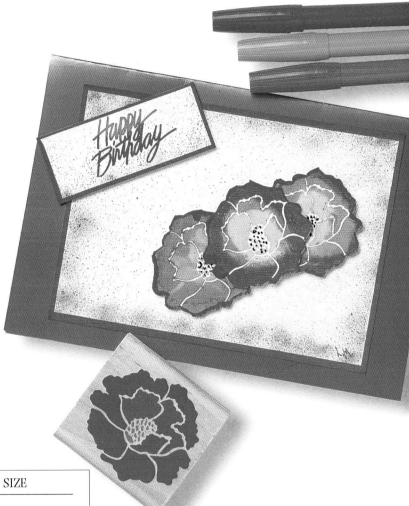

Cut out the three flowers. Stick the two outside flowers in place on the card (see finished card) with double-sided adhesive tape.

Position the centre flower and attach with foam-backed, double-sided tape to give depth to the appearance.

Stamp 'Happy Birthday' on a small piece of card. Use yellow and red markers and the sea sponge to decorate the edges of both cards.

THE STAMPS REDUCED IN SIZE

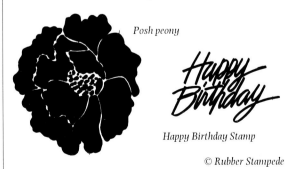

Posh peony

Happy Birthday Stamp

© *Rubber Stampede*

Edge both cards with a red marker. Attach the 'Happy Birthday' with foam-backed, double-sided tape as shown on the finished card and fix the card to the gold backing card with double-sided adhesive tape.

Alternative stamp designs: violets, flower basket, sunflower, graceful butterfly, rose.

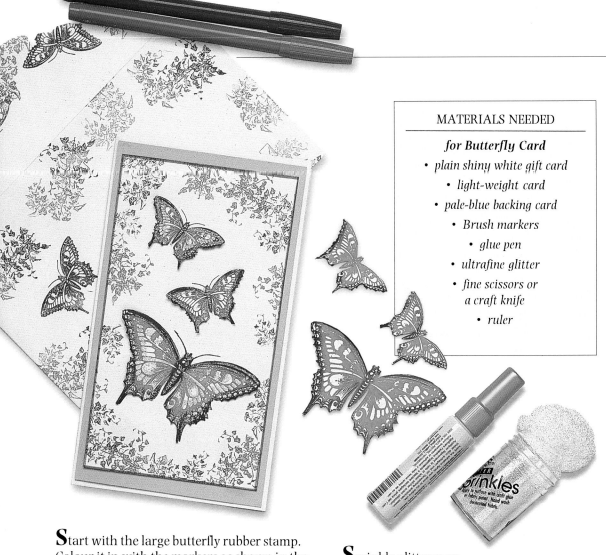

Start with the large butterfly rubber stamp. Colour it in with the markers as shown in the illustration and stamp on to the front of the card just below the centre. Stamp ivy in the same way. Repeat the same process for the two medium butterflies. Stamp the same butterflies on to the light-weight card. Use the glue pen and lightly draw on the card wherever you would like some glitter.

Sprinkle glitter over the light-weight card butterflies, brush off excess glitter and return it to the container. Cut around these butterflies, crease through the centre of the body of each one and mount them on top of the original butterflies, with their wings slightly folded up. Use a ruler to edge the card in mauve then mount it on the blue card.

THE STAMPS REDUCED IN SIZE

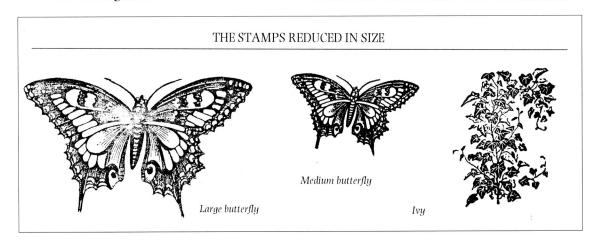

Large butterfly

Medium butterfly

Ivy

COSMIC STAMPING

Designed by Robyn Jaques

Rich golds and shining silvers set against midnight blue are used for these projects with a celestial theme. Moon, star and planet stamps are used to create a unique cosmic clock, a decorative planter, hanging stars and some elaborate boxes. Simple to make, each of these projects would enhance any setting and make an ideal gift for a soul mate.

<table>
<tr><td>

MATERIALS NEEDED

for all Projects
- *fine sandpaper*
- *sealer*
- *acrylic paint: pthallo blue*
- *paint brushes*
- *plate*
- *embossing ink*
- *embossing stamp pad*
- *embossing tinsels: gold, silver*
- *embossing powders: gold, silver*
- *A4 or quarto paper*
- *heat gun, toaster or hotplate*
- *spray gloss varnish*

</td><td>

MATERIALS NEEDED

for Cosmic Clock
- *wooden clockface with numbers and all moving parts*

</td></tr>
</table>

Lightly sand the clock, apply sealer and allow to dry thoroughly. Paint with two or three coats of pthallo blue acrylic paint. Leave to dry after each coat of paint.

Squeeze some embossing ink on to the plate and then, with a small brush, carefully paint around the bevelled edge of the clock. Only do one side at a time and avoid getting ink on the painted surface.

Embossing tinsel is used in the same way as the powder for embossing.

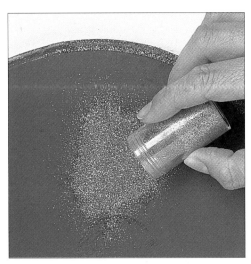

Lay paper on your work surface, underneath the clock, and carefully pour gold embossing tinsel over the wet embossing ink. Shake off the excess tinsel and, using a soft dry brush, remove any excess tinsel from the clock edge. Set with a heat gun.

Using the assorted stamps and referring to the finished clock (page 23), stamp your design on to the front of the clock with the embossing stamp pad. Apply firm, even pressure. Embossing ink is slow drying, so you can stamp several images and then apply the embossing tinsel. Plan your design and stamp all areas which require the one colour tinsel at the same time.

Use the tinsel liberally. Shake excess away on to a sheet of paper and return it to the bottle.

Melt the tinsel, using the heat gun. When the clock face is complete, lightly spray it with one coat of gloss varnish and leave to dry. Attach the clock numbers.

To emboss the hands of the clock, simply press them into the embossing ink pad, place them on a sheet of paper and sprinkle on the tinsel. Carefully pick them up, shake off the excess and heat to melt. Assemble the clock pieces to complete.

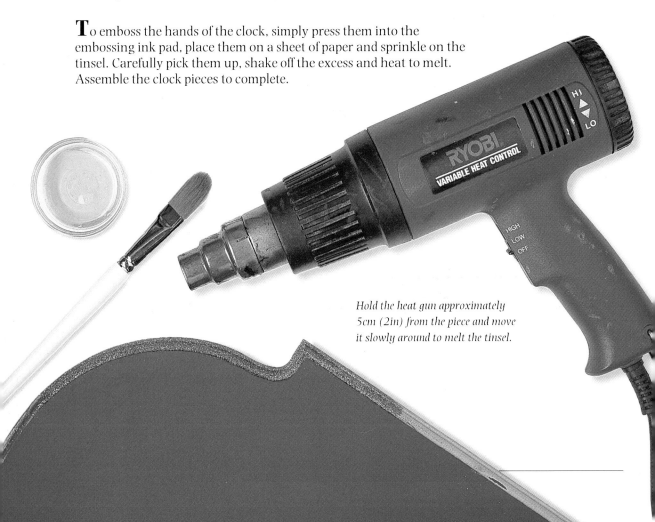

Hold the heat gun approximately 5cm (2in) from the piece and move it slowly around to melt the tinsel.

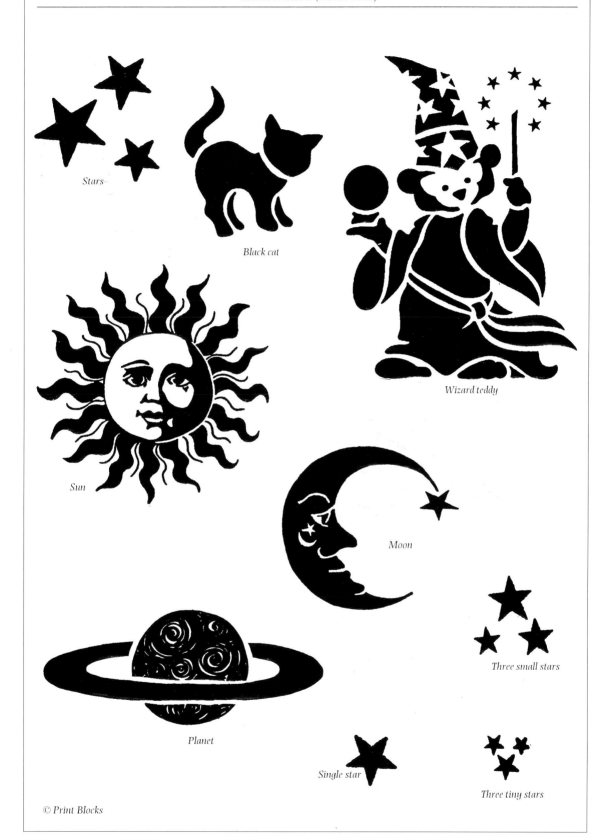

Stars

Black cat

Wizard teddy

Sun

Moon

Three small stars

Planet

Single star

Three tiny stars

MATERIALS NEEDED

for Planter

- *small terracotta pot*

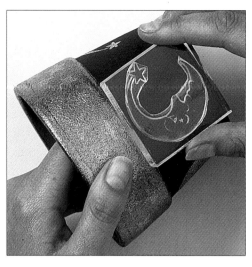

Seal the pot inside and outside with the sealer. Paint the outside of the pot below the rim in blue. Paint embossing ink around the rim of the pot and apply gold embossing tinsel, heat set.

Stamp random stars around the embossed rim using the embossing ink and small-stars stamp and apply silver embossing powder.

If the first stamping does not give a clear image, re-ink your clear positional stamp and align it carefully before re-stamping the image.

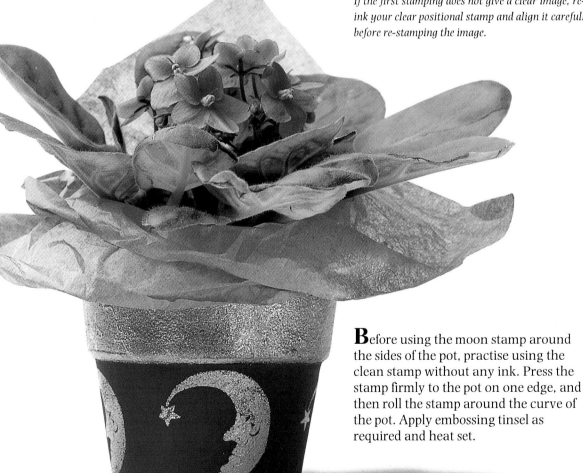

Before using the moon stamp around the sides of the pot, practise using the clean stamp without any ink. Press the stamp firmly to the pot on one edge, and then roll the stamp around the curve of the pot. Apply embossing tinsel as required and heat set.

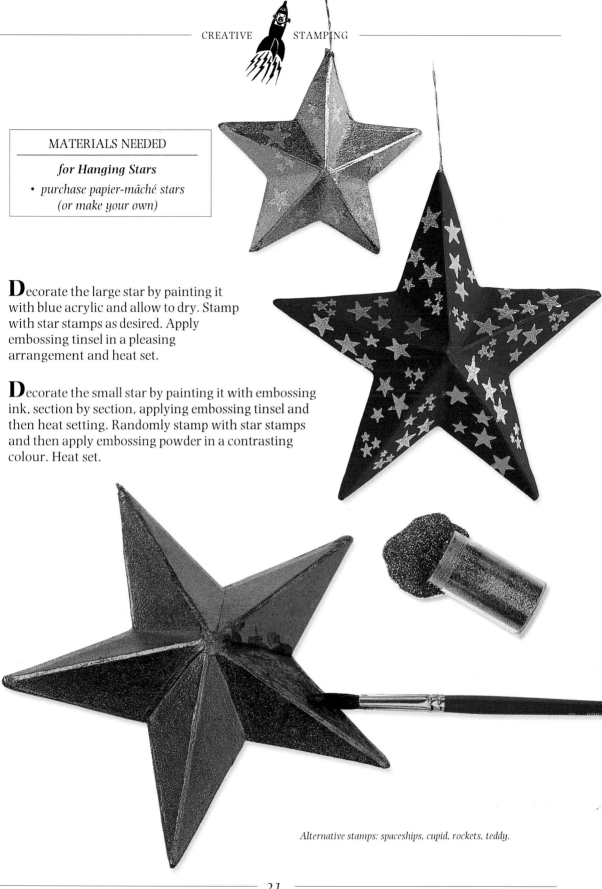

MATERIALS NEEDED

for Hanging Stars
- *purchase papier-mâché stars (or make your own)*

Decorate the large star by painting it with blue acrylic and allow to dry. Stamp with star stamps as desired. Apply embossing tinsel in a pleasing arrangement and heat set.

Decorate the small star by painting it with embossing ink, section by section, applying embossing tinsel and then heat setting. Randomly stamp with star stamps and then apply embossing powder in a contrasting colour. Heat set.

Alternative stamps: spaceships, cupid, rockets, teddy.

For the star box, paint the entire box with pthallo blue and leave it to dry. Stamp on your design with embossing ink, apply the embossing powders and heat set. If necessary, use an embossing brush marker to touch up any spots missed by the ink. Finish in the same way as the clock.

MATERIALS NEEDED
for Star & Moon Boxes
• purchased papier-mâché boxes *(or make your own)*

For the moon box, squeeze some embossing ink on to a saucer and use a brush to generously coat the outside of the lid of the box. Place the lid on a sheet of paper and sprinkle on the gold embossing tinsel. Shake off the excess tinsel and heat set.

Using star stamps and the embossing stamp pad, stamp stars randomly over the lid of the box. Sprinkle on the silver embossing powder, shake off any excess and return it to the container. Heat set. Paint the box base and the inside of the lid with pthallo blue.

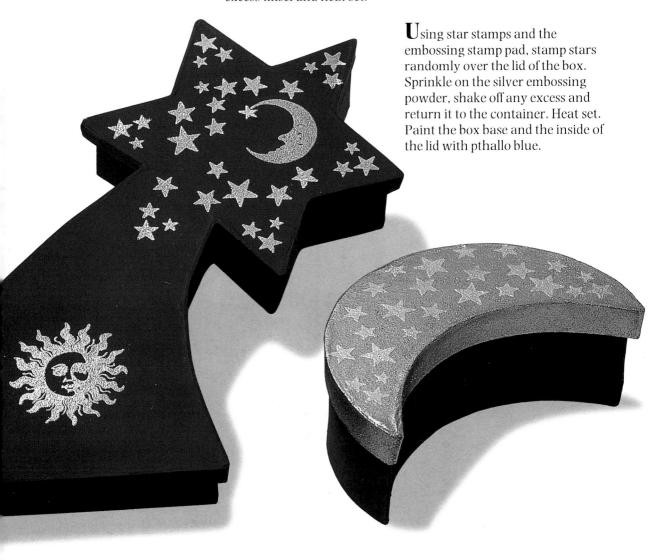

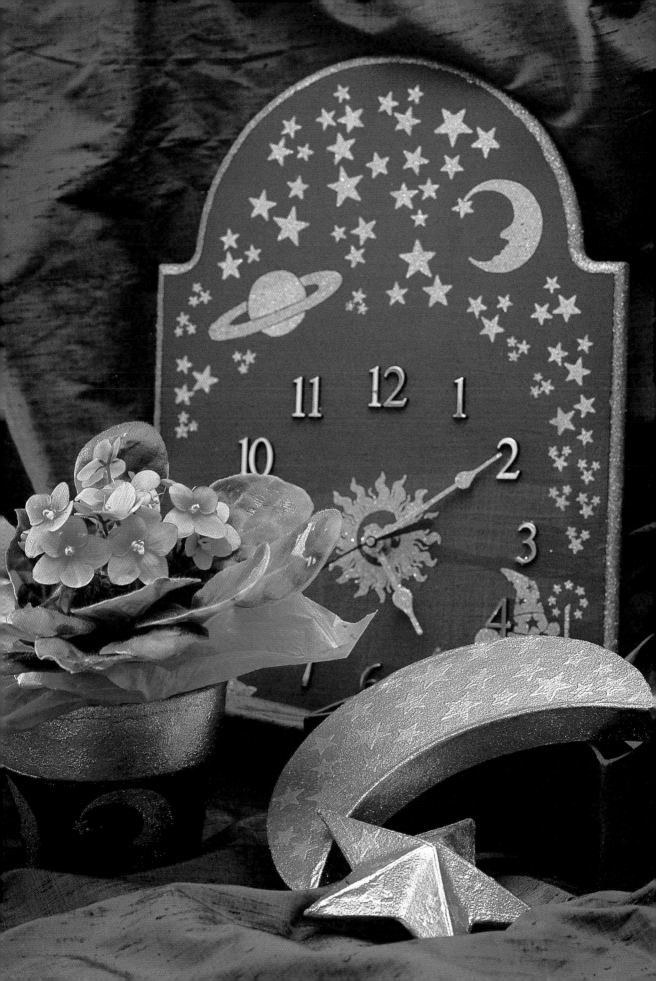

SILK-PAINTED CARDS

Designed by Robyn Jaques

The delicate art of silk painting is made easy in this project through the use of stamps. Design beautiful silk insets with golden stamped images floating on a watercolour background. These insets can be used to create exquisite cards, suitable for life's most joyous and festive occasions.

Stamping and embossing on silk yield the same effect as traditional silk painting using gutta. The embossing powder, when heated, soaks into the fibre and prevents the flow of dye. It is important to choose a stamp design which has open areas for colour, and fairly solid, fully enclosing outlines. If the lines of the design are too fine they will not hold the dye.

This technique is perfect for card insets and other decorative pieces. It is not suitable for use on items which will need to be washed as dye-painted, embossed silk cannot be steam fixed, therefore the dyes will not withstand washing.

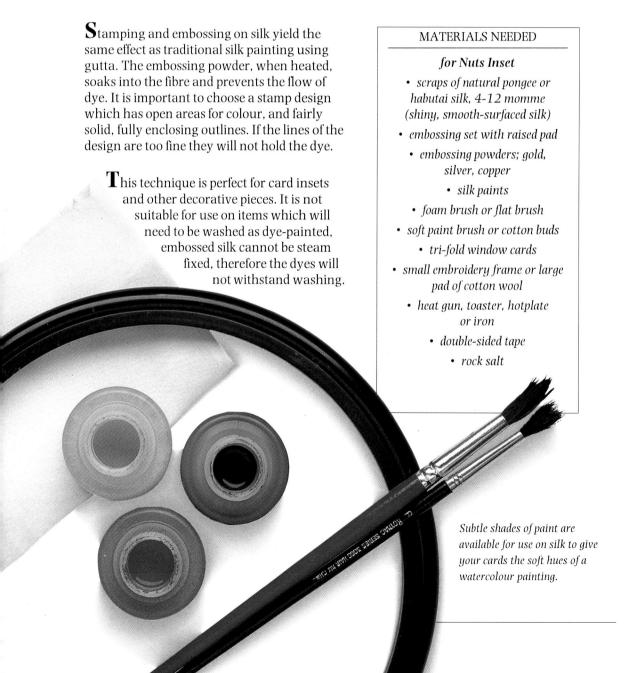

Subtle shades of paint are available for use on silk to give your cards the soft hues of a watercolour painting.

MATERIALS NEEDED

for Nuts Inset

- *scraps of natural pongee or habutai silk, 4-12 momme (shiny, smooth-surfaced silk)*
- *embossing set with raised pad*
- *embossing powders; gold, silver, copper*
- *silk paints*
- *foam brush or flat brush*
- *soft paint brush or cotton buds*
- *tri-fold window cards*
- *small embroidery frame or large pad of cotton wool*
- *heat gun, toaster, hotplate or iron*
- *double-sided tape*
- *rock salt*

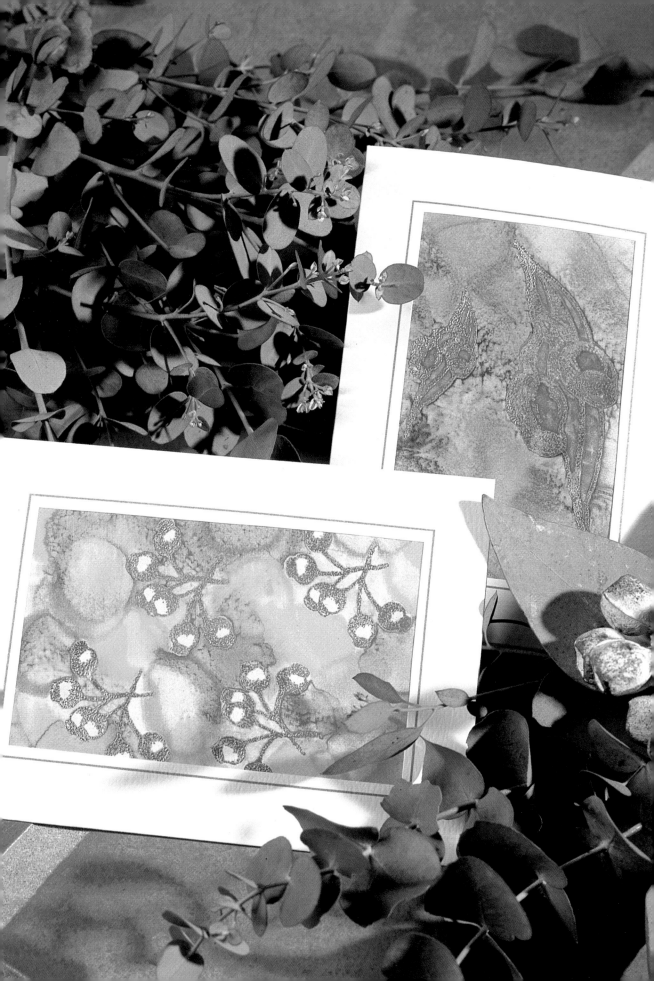

Cut a long thin strip of silk, approximately the width of the tri-fold card. From this you can make six to eight inset panels for the window cards as shown. Stamp the design on the fabric using embossing ink. Sprinkle on the metallic embossing powder, and shake off the excess. Heat the fabric to melt the powder. A heat gun is the easiest to use but you can hold the fabric above a toaster or the back of the fabric near an iron. Do not overheat the fabric, use just enough heat to cause some of the powder to soak through the fabric.

Check the back of the fabric to ensure the design is clearly showing through. If there are any visible gaps in the stamped lines, use an embossing pen with a brush marker tip to add more powder to complete the design. Heat carefully.

HELPFUL HINT

Always work on a smooth flat surface with a freshly inked embossing pad. Stamp your design by applying firm, even pressure. Use an embossing pen to touch up any gaps.

To colour the designs, stretch your fabric on a frame or pin or tape it to a large pad of cotton wool. Use a soft brush or cotton bud to apply dye to the centre of each area to be coloured. The dye will spread outwards, and the colour will be contained within the embossed lines. For a softer shade of colour, wet the silk with water before adding dye colour.

Emboss in gold prior to painting with the silk paints.

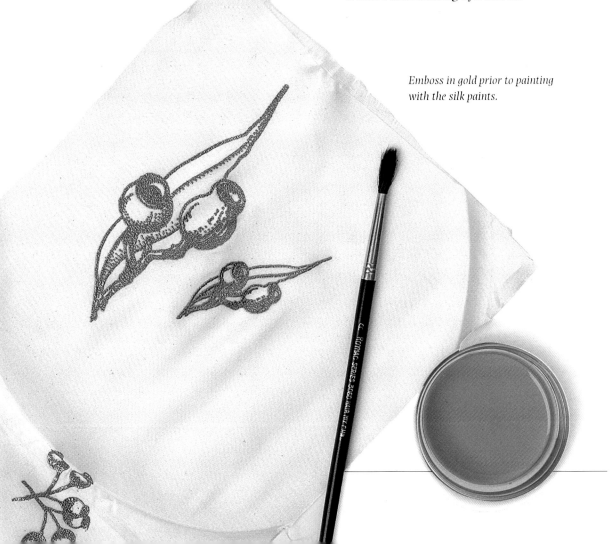

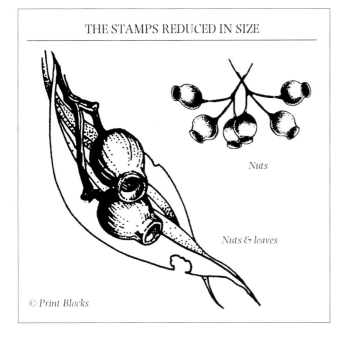

THE STAMPS REDUCED IN SIZE

Nuts

Nuts & leaves

© Print Blocks

Do not overload the brush with dye otherwise it will flood over the lines. Paint in smooth slow strokes. For subtle shading, go over freshly dyed areas using other complementary colours.

To get two colours to blend, paint the second colour while the first is still wet, rubbing gently with the brush where the two colours meet.

Water can be used to soften a hard edge or to spread out the dye and lighten the colour. Use a larger brush for the background and work quickly to prevent the edges from drying out as you apply more paint.

To make up the cards, apply strips of double-sided tape around the edges of the window on the wrong side of the card and peel off the backing paper. Lay your embossed silk on a flat surface, right side up. Lower the card on to the silk, aligning the design in the window of the card. Press down firmly to secure the silk to the tape. Trim away excess silk and fold the flap of the card over to hide the raw edges. Secure with tape or glue along the fold line.

ALCOHOL TECHNIQUE –

Use a cotton bud dipped in some methylated spirits to stroke or dab over a dyed area where the inks have dried. The pigment will disperse, forming a light area with dark-lined edges. Water will produce a similar result, though not as effectively.

SALT TECHNIQUE –

Sprinkle salt on to damp, freshly painted silk to produce a mottled effect. The background shown on the card was created by randomly dripping colours from the brush, and allowing the dyes to mix on the fabric. Fine rock salt was sprinkled on the wet dye and brushed off when it had dried.

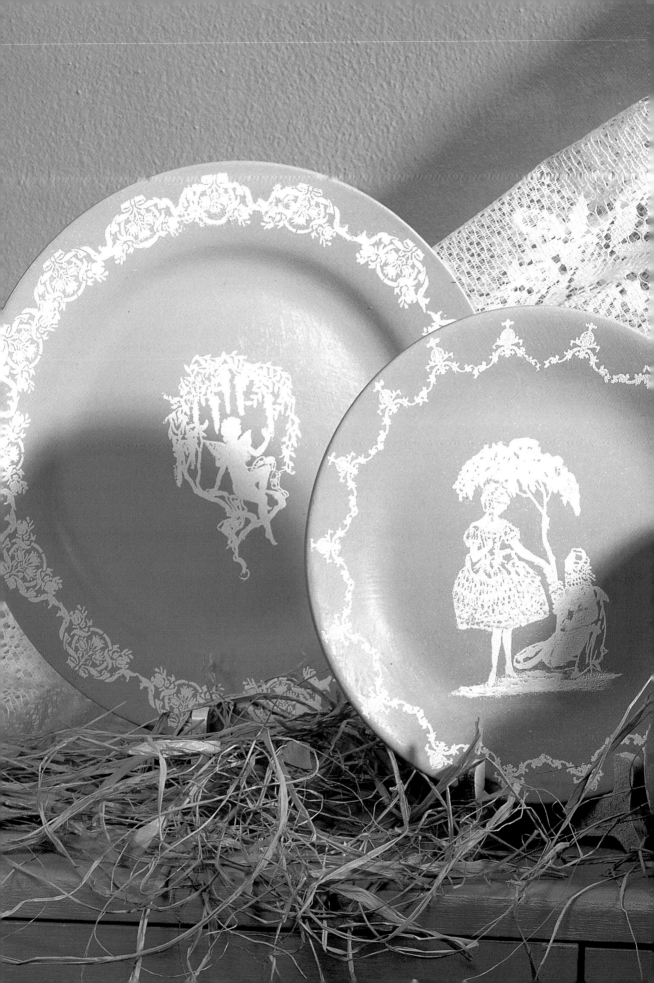

IMITATION WEDGEWOOD

Designed by Trish Hend

Wedgewood is a name that suggests elegance, quality and a daunting price tag. However, with a little creative stamping, and some recycled china, you can create your own, very convincing, imitation Wedgewood pieces.

MATERIALS NEEDED

for Imitation Wedgewood Plate

- *old china plate*
- *acrylic paints: sapphire blue, warm white, mid yellow*
- *artists' acrylic medium water-based matt varnish*
- *sponge brush*
- *soft round No. 2 brush*
- *blank dry stamp pad*
- *sheets of white scrap paper*
- *embossing powder: Wedgewood white*
- *cotton buds*
- *clear matt varnish (optional)*
- *oven preheated to 150°C (300°F)*

Wash the plate thoroughly with a mixture of vinegar and water. Rinse it and let it dry completely. Mix three parts of sapphire blue to one part of warm white. Add a speck of mid yellow to the mixture and blend it in thoroughly. Pour some water-based matt varnish into the mixture so that you have equal amounts of the paint and the varnish.

Hold the plate in the palm of your hand with your fingers touching the rim only (the paint will not adhere to any finger marks). With a sponge brush, paint the top surface of the plate with the prepared paint mixture. Allow at least one and a half hours between coats, and apply two to three coats in total. When the final coat on the top surface has dried fully, paint the underside of the plate following the same process. Air dry for about two hours. Clean the sponge brush with soap and water.

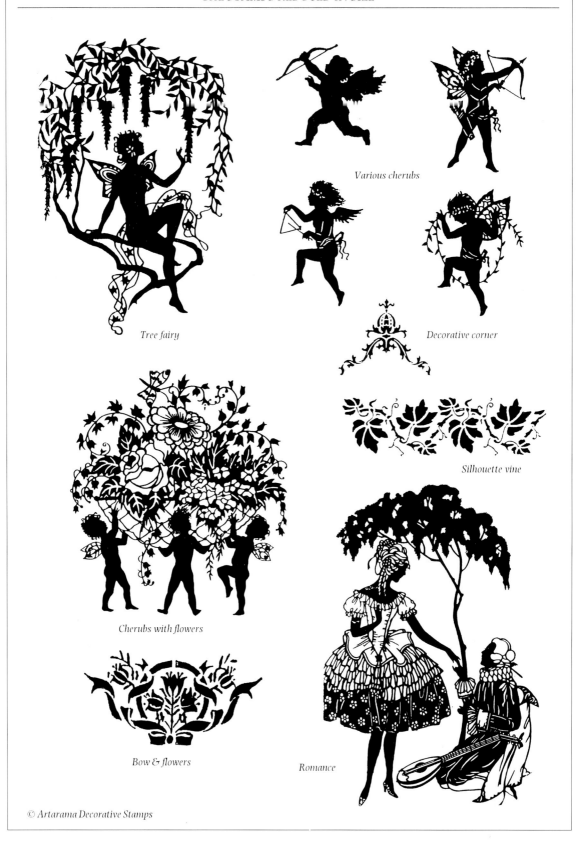

Tree fairy

Various cherubs

Decorative corner

Silhouette vine

Cherubs with flowers

Bow & flowers

Romance

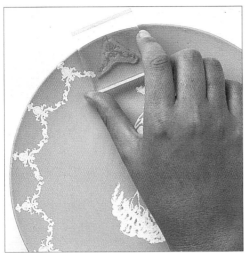

Although the plate is intended for decoration rather than household use, it will withstand hand washing in warm soapy water.

Preheat the oven to 150°C (300°F) and 'cook' the painted plate for thirty to forty-five minutes. Turn off the oven and leave the plate in the oven until it has cooled. Be careful when opening the oven door as any sudden cooling may cause the china to crack.

Select the stamps you would like to use: a large one for the centre and a smaller, complementary design for the border around the outer edge. Prepare the dry stamp pad by rubbing embossing fluid on the pad and letting it soak in. Add more fluid as necessary. Place a large sheet of scrap paper on your work surface to catch any excess embossing powder.

Remove the cold plate from the oven and place it on the scrap paper. Test the size and positioning of the central design by stamping it on to a piece of tracing paper and placing it over the plate. When you are confident that your design fits in the centre of your plate, stamp it on to the plate with embossing fluid. Wipe away any unwanted fluid with a cotton bud.

While the fluid is still wet (it takes around eight minutes to dry), generously sprinkle some of the Wedgewood white embossing powder over the image. To remove any excess powder, blow gently, or lightly dust with a small dry brush on to the surrounding paper.

Stamp the border images around the plate and repeat the embossing-powder process as above.

Preheat the oven to 150°C (300°F). Place the plate in the oven and leave it until the embossing powder is dry – about five to eight minutes. Now turn off the oven, but leave the plate inside until it is completely cool. A coating of crystal clear varnish may then be applied to preserve your work.

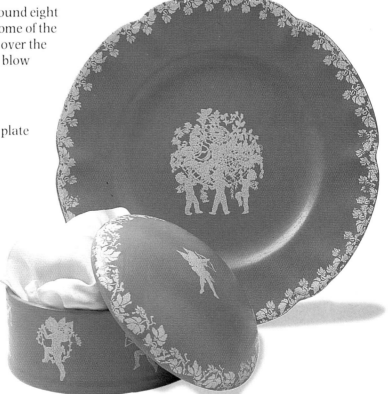

CAKE DECORATING

Designed by Trish Hend

This unique project involves stamping delicate and pretty images on to an iced cake. Pastel pictures in edible pinks and mauves, or other colours of your choice, are set on the cake using see-through stamps. Take a photograph of the finished cake before you serve it, as it will be eaten in a flash.

Leave the iced cake for approximately three days to dry properly before stamping. Lay all the required equipment out on newspaper.

Prepare the ink pad using a 15 x 15cm (6 x 6in) piece of felt placed on top of a piece of tin foil. Decide which colours you intend to use for the stamped design and pre-mix the food colouring, i.e., red and blue for violet, red and yellow for orange, etc. One at a time, pour the colours on the felt in strips about 25mm (1in) wide. Always make sure that the stamp pad is on an even, flat surface.

MATERIALS NEEDED
for Decorated Cake
• *fondant-icing covered cake*
• *tin foil*
• *light coloured felt*
• *bristle brush*
• *food colourings: red, yellow, blue, green*
• *newspaper*
• *paper towel*
• *lint-free clean cloth*
• *paper*

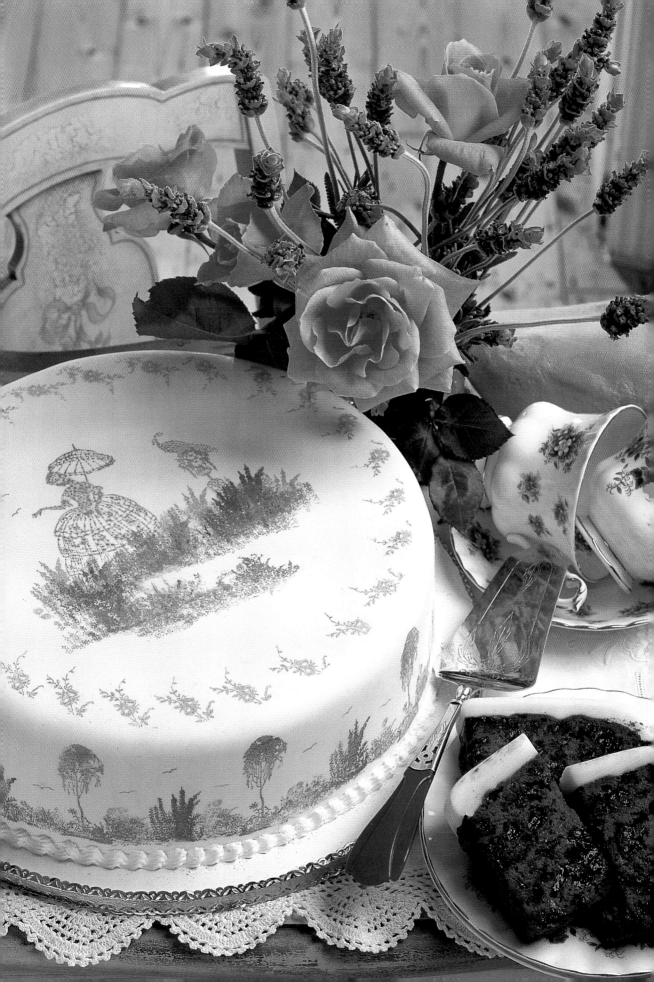

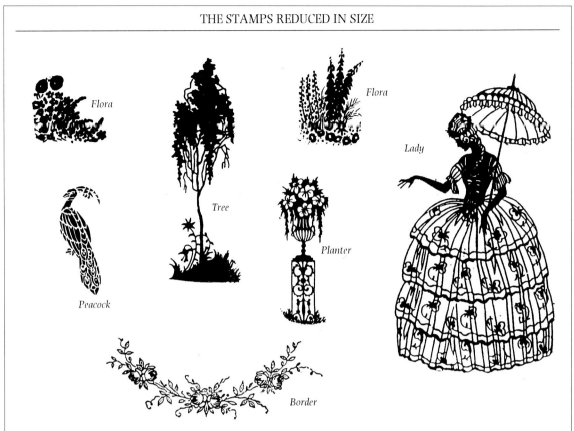

THE STAMPS REDUCED IN SIZE

Flora

Flora

Lady

Tree

Planter

Peacock

Border

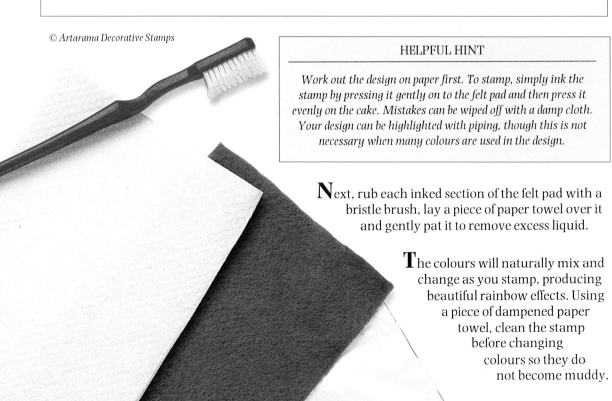

HELPFUL HINT

Work out the design on paper first. To stamp, simply ink the stamp by pressing it gently on to the felt pad and then press it evenly on the cake. Mistakes can be wiped off with a damp cloth. Your design can be highlighted with piping, though this is not necessary when many colours are used in the design.

Next, rub each inked section of the felt pad with a bristle brush, lay a piece of paper towel over it and gently pat it to remove excess liquid.

The colours will naturally mix and change as you stamp, producing beautiful rainbow effects. Using a piece of dampened paper towel, clean the stamp before changing colours so they do not become muddy.

IRIS SILK SCARF

Designed by Jane Smith

The beauty of silk painting has long been admired. This scarf, with its combination of rich flowing cream silk and the deep purple of the iris is quite gorgeous. While silk stamping is a simpler technique than silk painting, it will still allow you to achieve a look which compares with the finest of silk paintings.

MATERIALS NEEDED

for Iris Scarf

- 1 metre (36in) pure silk fabric
- pure soap
- black fabric ink
- blank stamp pad or fabric ink cushions
- paper
- fabric ink stamp cleaner
- embroidery hoop, or wooden frame and drawing pins
- gutta
- applicator bottle fitted with a nib
- silk dyes: pink, purple, mauve, blue, yellow and green
- no. 6 paint brush
- jar of water
- fabric ink pens: pink, purple, mauve, blue, green

Wash the silk in hot water and pure soap. Rinse well and allow to dry out of sunlight. Hem any raw edges. Saturate the stamp pad or fabric ink cushions with the black fabric ink. Ink the stamp thoroughly before use. Before stamping on the fabric, test the design on a piece of paper. Re-ink the stamp and then stamp firmly in place on the silk. Stamp the design over the fabric in a pleasing arrangement, re-inking well before each stamping.

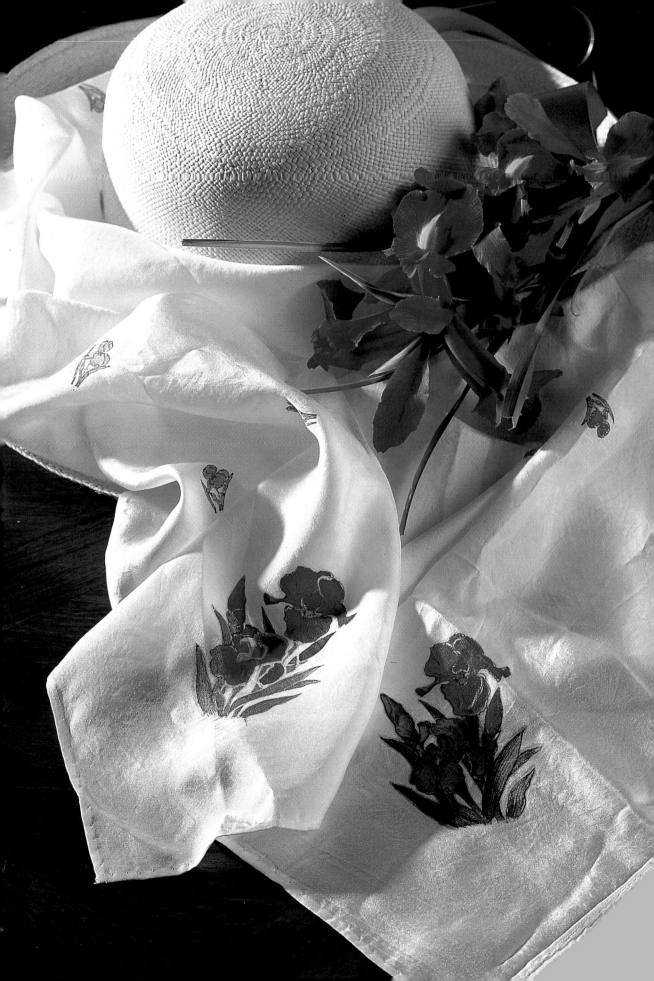

When you have completed the design, clean the stamp with fabric ink stamp cleaner before the ink dries. Stretch the silk on to an embroidery hoop or pin it to the frame making sure it is taut. Fill the applicator bottle with gutta and trace evenly around the outline of the stamped design (as shown in the illustration below) making sure all lines are joined to prevent the dye from spreading.

Large iris – use the paint brush to apply a small amount of water and then add a small dab of silk dye to paint the design. Refer to the finished project for the placement of colours.

HELPFUL HINT

After the silk has dried the dye must be steam fixed. The brand and type of dye used will determine how this is done. Follow the manufacturer's instructions carefully to fix the dye.

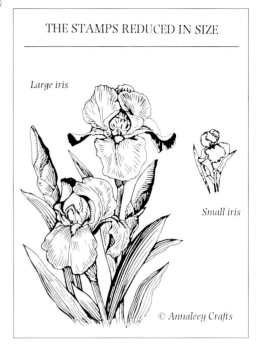

THE STAMPS REDUCED IN SIZE

Large iris

Small iris

© Annaleey Crafts

Small iris – using fabric ink pens and a gentle dabbing motion, colour in the image. Be careful to only add very little ink so that the colours stay within the design.

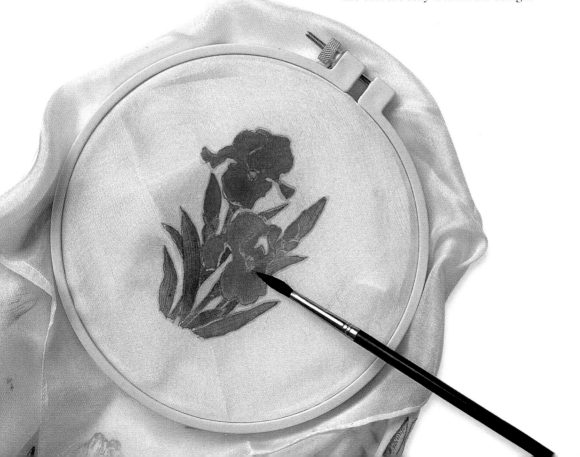

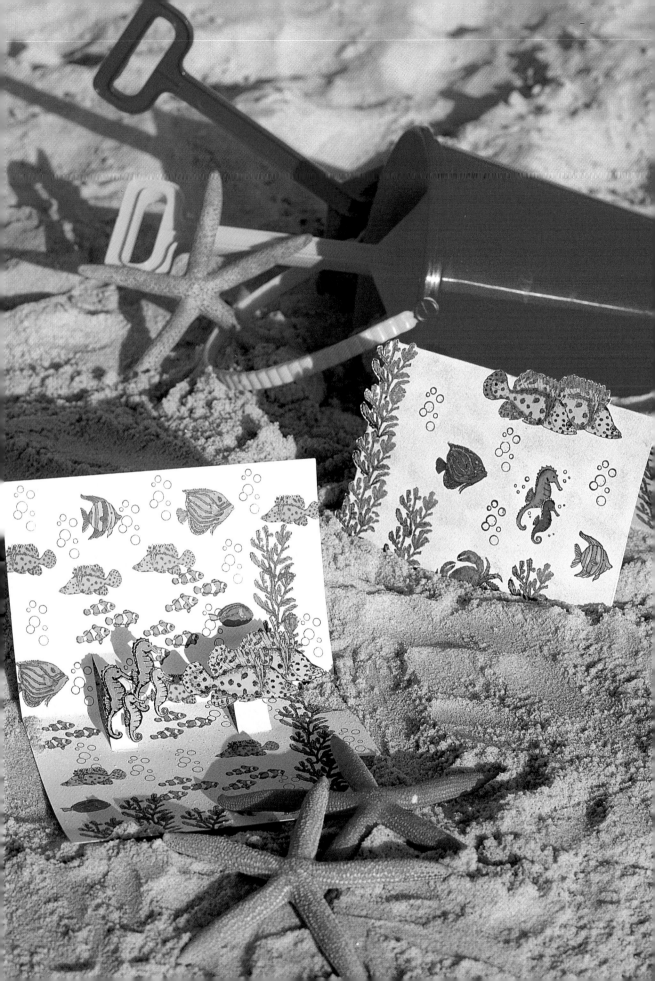

UNDER THE SEA

Designed by Barry Wakeham

There is nothing quite like being beside the sea to lift your spirits and restore that sense of joy in life. These refreshing seaside cards are just the trick to let someone know that you are thinking of them and wishing them well. The delightful pop-up effects will bring a smile to any face.

MATERIALS NEEDED

for Seaside Cards

- light-weight white card
- craft knife & mat
- ruler & pencil
- pigment ink pads: black, green, blue
- embossing powder
- brush markers: green, yellow, blue, orange, crimson, purple
- fine scissors
- double-sided tape
- small sponge

Cut two pieces of light-weight card to the required size, making one piece slightly larger all round than the other. The larger piece is for the outside of the card, the smaller one for the inside. Draw a pencil line across each card where you want the fold line to be (see diagram on page 40).

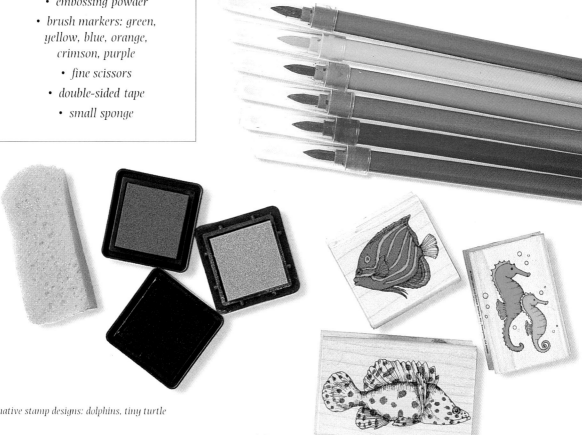

Alternative stamp designs: dolphins, tiny turtle

On the large piece of card stamp one fish over this line and, using a mask, another one behind it. Emboss and colour these two fish. Using a craft knife, cut around the top outline of the fish down to the dotted pencil line. Fold the card on the line and the fish will pop up above it.

Fold the smaller sheet along the fold line, open it up again and cut two slits 10mm ($^3/_8$in) apart, each about 30mm ($1^1/_4$in) long, either side of the fold line as shown at right. Fold the card again, pushing the cut tabs to the inside. Close completely and press the ends of the tabs to make hinges.

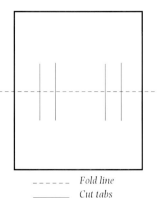

- - - - - Fold line
———— Cut tabs

Stamp small fish and seahorses on another piece of card, using masks to overlay them, and then emboss and colour them. Cut out the individual items and attach them to the inside tabs with the double-sided tape. These fish will pop out of the open card. Stamp a design over the rest of the inside of the card, emboss it and then colour it in.

Stamp a seaweed border along the edge of the large card. Emboss and colour it and then cut down the outside edge with a craft knife.

Stamp the rest of the design on the front of the card, using masks where appropriate to create clusters of fish. Emboss and colour.

The background for both the inside and the outside of the card was created by dabbing with a sponge, inked on blue and green colour cubes. Finally, fix the inner card to the outer one with double-sided tape.

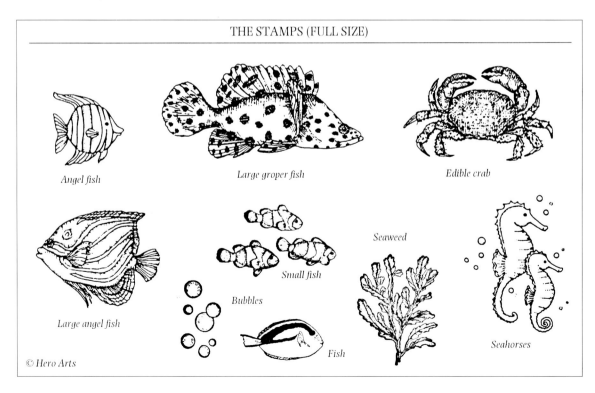

THE STAMPS (FULL SIZE)

Angel fish

Large groper fish

Edible crab

Large angel fish

Small fish

Bubbles

Seaweed

Fish

Seahorses

© Hero Arts

CELESTIAL TINWARE

Designed by Rixie Lord and Anjelika Vorel

Old tinware can be given a new lease of life with these heavenly stamping designs. You can make a matching set using any old pieces you have stored away or you could buy some pieces in your local second-hand shop or flea market. The finished items will make stunning serving dishes or centrepieces.

If your tinware is rusting or has a very rough finish, you will first have to scrub it with a wire brush and apply an appropriate rust treatment. Finish preparing the tinware by lightly sanding with the medium grade sandpaper. Carefully brush off any resulting dust.

Use masking tape to mask off half the plate. Overlap the strips of masking tape, making sure there are no gaps between the strips. Mask around the lid of the metal container ready to paint the gold (refer to the photo on page 45).

Spray the unmasked area of the plate and the metal container with gold paint. Leave to dry thoroughly and then apply another coat. Again, allow plenty of time for this second coat to dry.

MATERIALS NEEDED

for Celestial Tinware
- old metal plate
- old metal container
- medium-grade sandpaper
- enamel spray paints: black, gold
- masking tape
- craft glue
- pigment stamp pad: any colour can be used
- embossing powders: gold, blue foil, silver
- heat gun, toaster or hotplate
- gloss spray varnish
- fine-grade wet-and-dry sandpaper
- matt-gold wrapping paper
- scissors

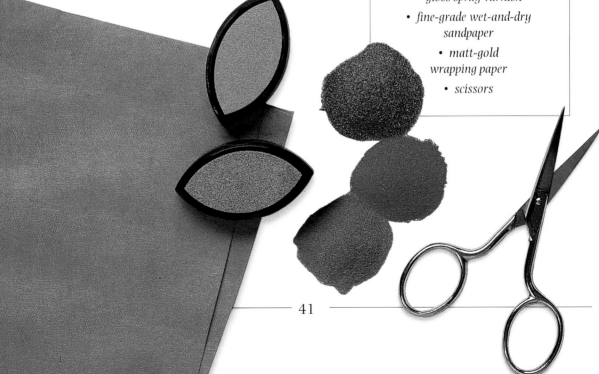

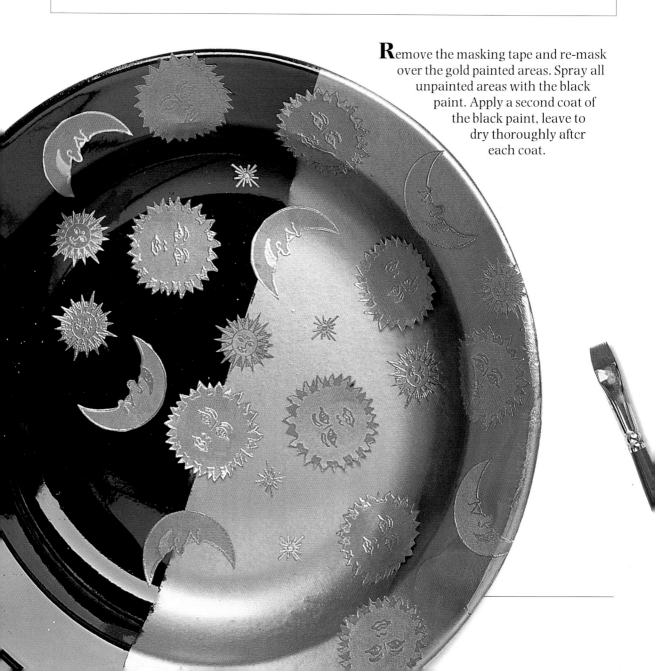

Sun

Small sun

Moon and sun

© thINKING Stamps

Remove the masking tape and re-mask over the gold painted areas. Spray all unpainted areas with the black paint. Apply a second coat of the black paint, leave to dry thoroughly after each coat.

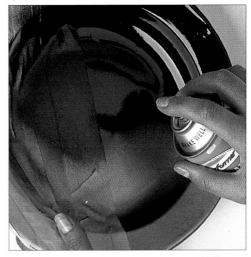

Stamp the different images on the matt-gold
wrapping paper using the pigment stamp pad.
Sprinkle on the embossing powder, varying
the colours for each image, shake off the
excess powder and heat set. Carefully cut out
the stamped images around the outside edges
of the embossing.

*Always spray in a well-ventilated area and follow
the manufacturer's instructions for use.*

Position the cut-outs on the plate and container,
moving them around until you are satisfied with the
layout, and then glue each one in place.

Leave to dry overnight and then varnish. When the
pieces are completely dry, sand lightly with the wet-
and-dry sandpaper and varnish again.

Alternative stamp designs: unicorn, fairy & stars.

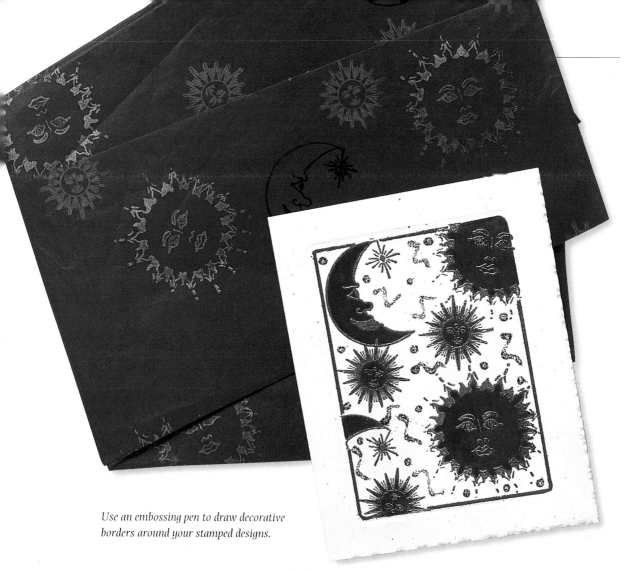

Use an embossing pen to draw decorative borders around your stamped designs.

MATERIALS NEEDED

for Wrapping Paper & Card

- Plain white card
- blue tissue paper
- pigment stamp pads: gold, black, light blue
- embossing powders: gold, silver, copper, blue
- blue glitter pen
- dark-blue marker
- heat gun, toaster or hotplate
- Post-it notes
- embossing pen

Mask around the outer edges of the plain white card with the Post-it notes (see photograph above). Then, one at a time, stamp the designs on the card. Work with each of the embossing powders separately, to ensure the colours don't get mixed up. First sprinkle the gold embossing powder on the stamped designs and return any excess to the bottle. Then repeat with the silver powder and finally the copper powder. Heat set.

Colour in the designs with the dark-blue marker. Draw the border with the embossing pen and emboss it with blue powder. Add dots and squiggles with the blue glitter pen.

Stamp all over the tissue paper with the assorted stamps and inkpads in a decorative pattern. Leave overnight for the pigment ink to dry properly.

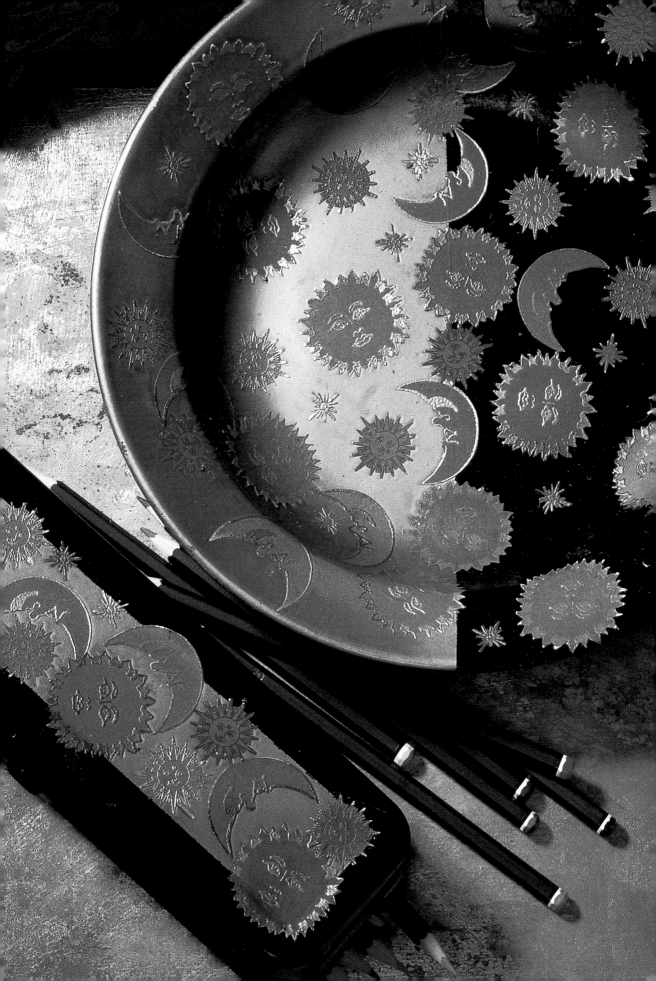

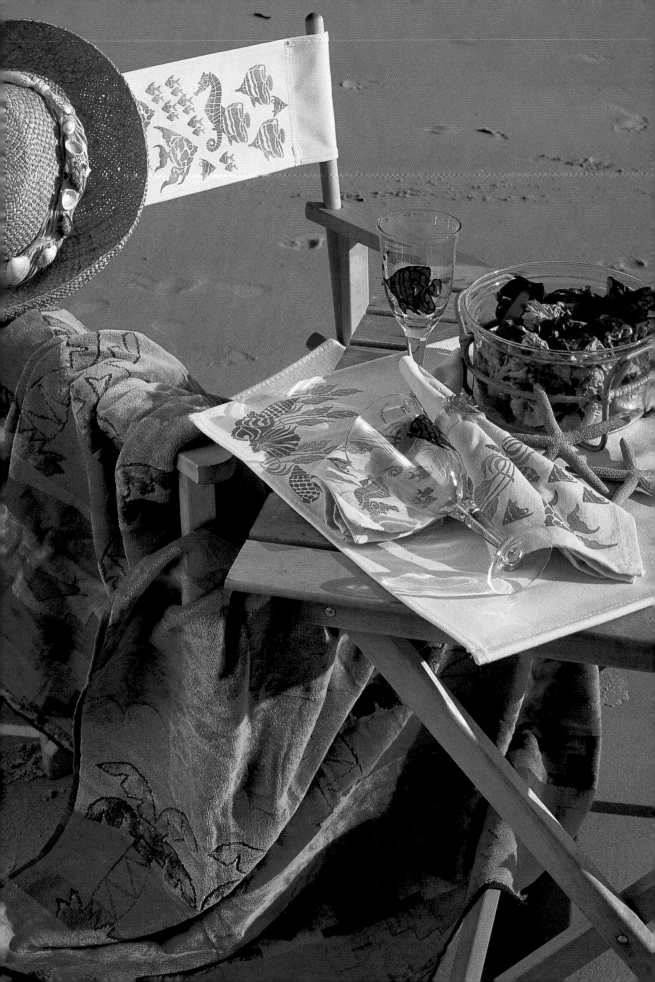

BY THE SEASHORE

Designed by Robyn Jaques

Bring the seashore into your picnic settings. There is something delightfully fishy about these designs which are used here, to wonderful effect, to create a theme setting which will be perfect for use in any outdoor area under the sun.

MATERIALS NEEDED

for all Projects

- *Twelve-colour pigment ink pad*
 - *embossing powders: clear, clear sparkle*
 - *paper*
 - *small craft scissors*
 - *heat gun, toaster or hotplate*

MATERIALS NEEDED

for Director's Chair

- *plain canvas director's chairs*

To stamp the design on to the director's chair, remove the fabric from the wooden supports and place it on a hard flat surface which is suitable for stamping. It may help to tape the fabric in position so that it will not move while you are stamping.

Work out the design and the colour combination you want to stamp. Using the twelve-colour ink pad, decide how you want the colours to appear, i.e., horizontally, diagonally, or vertically, and then carefully stamp the colours by gradually tapping the stamp to build up the colour. Be careful not to muddy the colours on the pad and avoid pressing the stamp too vigorously into the stamp pad.

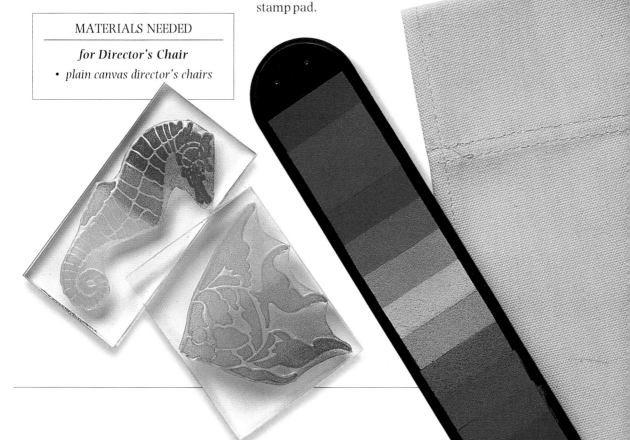

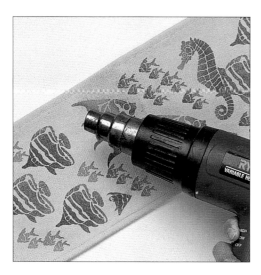

Use the heat gun on the low setting and take care not to scorch the fabric by getting too close.

Use a firm, even pressure and test your design out on paper first. If your first stamping is not clear, simply re-ink the positional stamp, line it up carefully over the original stamping and re-print. Next, sprinkle clear embossing powder heavily over the entire stamped design, shake off all excess powder and return it to the container. Using a heat gun 5cm (2in) from the fabric, melt the powder to fuse the colours to the fabric. A toaster or hotplate can be used instead.

The canvas can be handwashed in cold water. Lay it flat in a shady place to dry. Iron the reverse side – never iron directly on the embossed surface.

Alternative stamps: shell, crab, seal.

DETAILS OF DESIGN

Use repeat stampings of the small fish to create schools.

Create rainbow effects with the twelve-colour pad.

Use masks to create the layering effect.

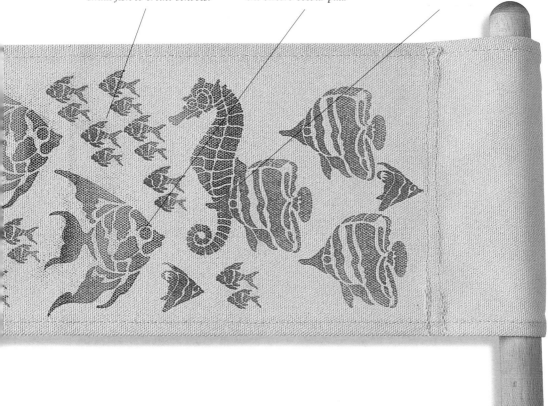

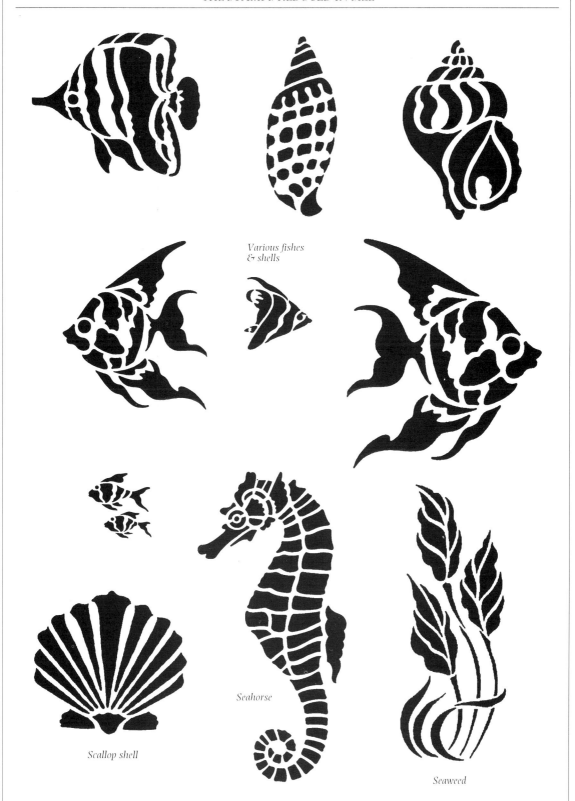

Various fishes & shells

Scallop shell

Seahorse

Seaweed

MATERIALS NEEDED

for Napkin Rings
- *Shrink plastic kit*
- *over preheated to 150°C (300°F)*
- *baking tray, lined with baking paper*
- *super glue gel*

Two sheets of shrink plastic will make four napkin rings. Using the sandpaper in the kit, and working with a circular action, roughen one side of each sheet of plastic. Cut one of the two plastic sheets lengthwise into four equal strips.

Press the sanded side of the strips across the ink pad. Lay the strips on scrap paper and sprinkle them with clear sparkle embossing powder. Shake off the excess.

Place the strips in the baking tray, powdered side up, and bake them for three to five minutes. If the strips begin to curl, carefully flatten them. Remove them from the oven and, working quickly, bend each strip to form a ring (embossed side out). Try not to touch the embossed surface until it has cooled. If the strip cools before you have sufficiently bent it, return it to the oven for a few more minutes.

Stamp the seaweed design (inked in the green area of the pad) four times on the second plastic sheet. Now, using other parts of the twelve-colour ink pad, stamp two seahorses and two angel fish on to the second sheet. Cut out all the designs without touching the ink. Sprinkle on the clear sparkle embossing powder and bake them as before. Glue a fish or a seahorse on to a piece of the seaweed and then glue it in position over the join in the napkin ring. Repeat for each napkin ring.

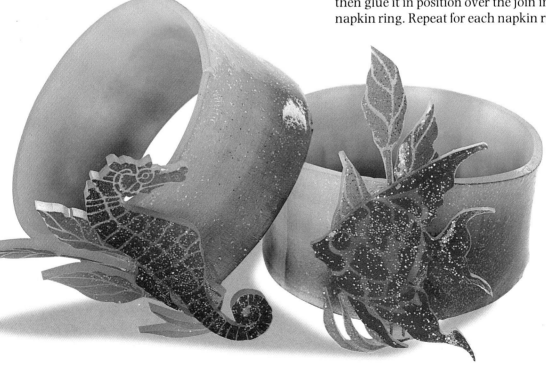

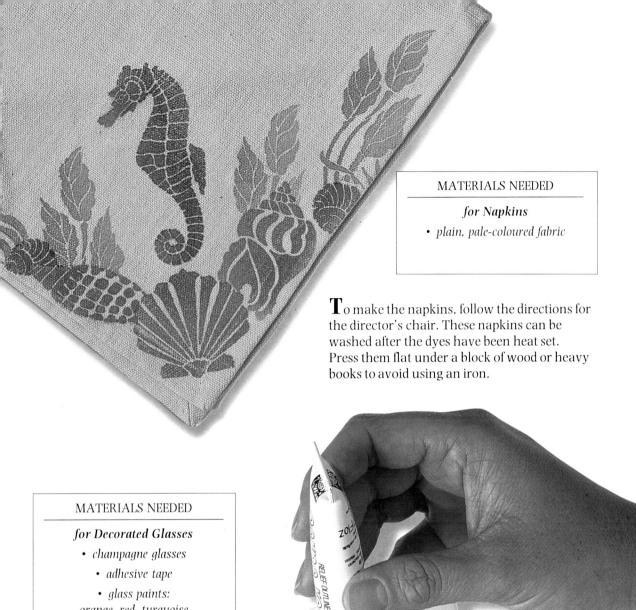

To make the napkins, follow the directions for the director's chair. These napkins can be washed after the dyes have been heat set. Press them flat under a block of wood or heavy books to avoid using an iron.

Thoroughly clean the glasses and then avoid touching the area to be painted. First, stamp your chosen design on a small piece of paper and tape it inside the glass, in the required position, so that the design faces through to the outside.

On the outside of the glass, trace around the design with the black cerne relief paint. Leave it to dry. Colour in the design with the glass paints. For extra durability, finish with a coat of clear glass varnish if desired.

TERRACOTTA POT

Designed by Tracy Barton

Decorate terracotta pots with this lively design in vibrant colours. The decorated pots can then be used in the garden for planting, or as handy storage pots in the home or office for items such as kitchen utensils, or desk accessories. Planted with a small, fragrant herb, one of these pots would make a fabulous gift for someone special.

Clean the pot with warm soapy water and dry it thoroughly. Inks will not adhere where there are marks on the surface. Hold the pot on the inside and work from the bottom area to the top edge.

Ink the stamp by placing the stamp pad on to the stamp. Make sure the stamp gets a thorough coating of ink. Because the pot has a curved surface, apply the stamp by rolling it smoothly across the surface.

MATERIALS NEEDED

for Decorated Pot

- *terracotta pot: any size*
- *slow-drying pigment inks: assorted colours*
- *embossing powders: clear or sparkling*
- *scrap paper*
- *paint brush*
- *sponge*
- *oven pre-heated to 200°C (390°F)*

Use a slow-drying pigment while you are working on this pot, as it will give you more time to complete each stage before the pigment sets.

Alternative stamp designs: lily, flower buds.

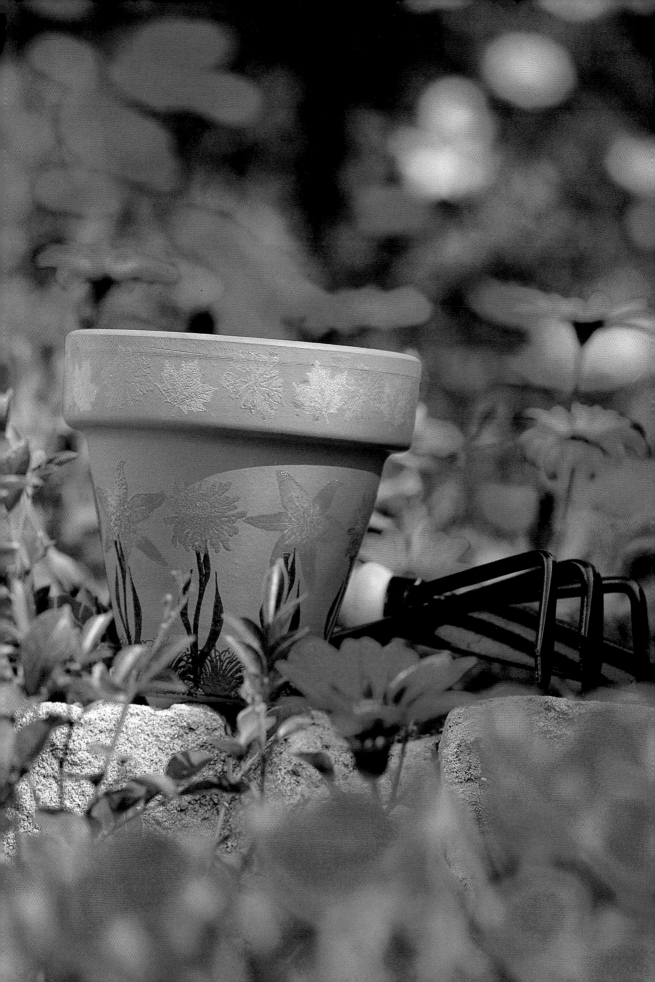

It is best to do the stamping a little bit at a time. For example apply the grass stamp three times in a row, then sprinkle liberally with the embossing powder. Use the scrap paper to capture excess embossing powder and return it to the bottle. Using the paint brush, gently brush any excess embossing powder away from any parts of the pot which you do not want embossed.

Do not heat set until you have completed the entire pot. Work your way around the pot, stamping and embossing each area of it until you have completed the design.

Apply the pigment on to the stamp by pressing the stamp pad firmly on to the stamp. This will give a more even coverage, and will ensure that the stamping has a complete image.

HELPFUL HINT

If you are working on a raw terracotta pot, you will get the best finish if the pot is thoroughly clean before you begin. You may need to use a stronger cleaner such as sugar soap for some stubborn marks. Alternatively, paint the pot so that you have a smooth surface for stamping.

Once you have finished your design, place the pot in an oven, preheated to 200°C (390°F) for five to seven minutes. When handling the pot prior to heating be very careful not to knock off any of the embossing powder.

It is a good idea to seal the pot with a general purpose sealer after the design has been set, as this will preserve your work and keep it looking fresh and new for much longer.

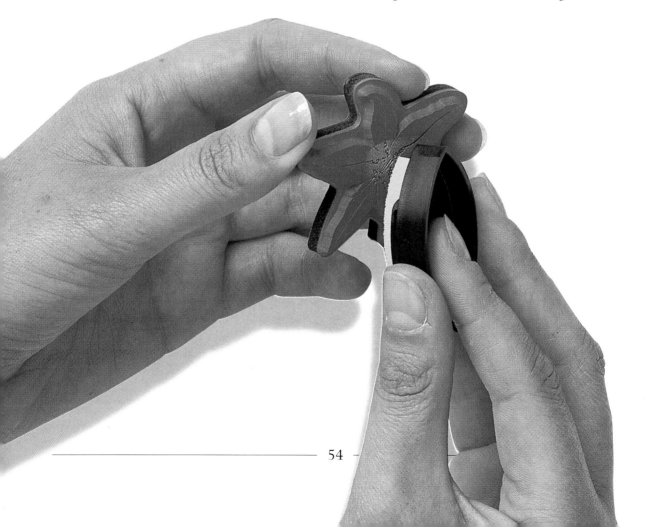

THE STAMPS (FULL SIZE)

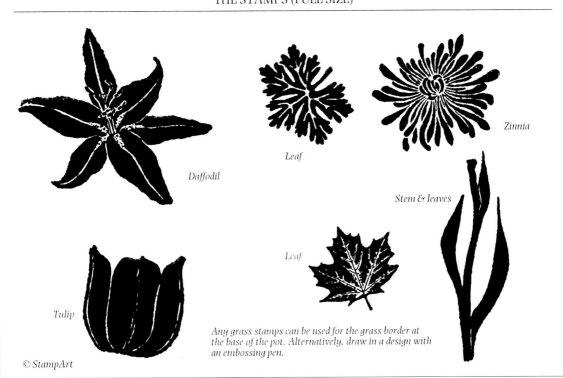

Daffodil

Leaf

Zinnia

Stem & leaves

Leaf

Tulip

Any grass stamps can be used for the grass border at the base of the pot. Alternatively, draw in a design with an embossing pen.

© StampArt

DETAILS OF FLOWER DESIGNS

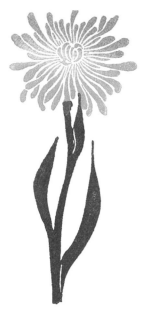

1. Zinnia in lilac, aqua and evergreen

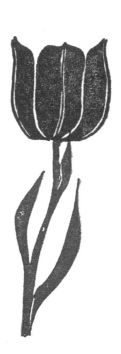

2. Tulip in cranberry and evergreen

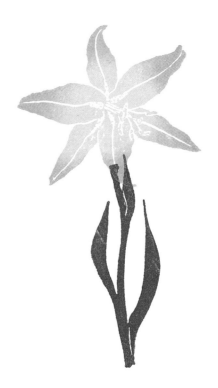

3. Daffodil in marigold, canary and evergreen

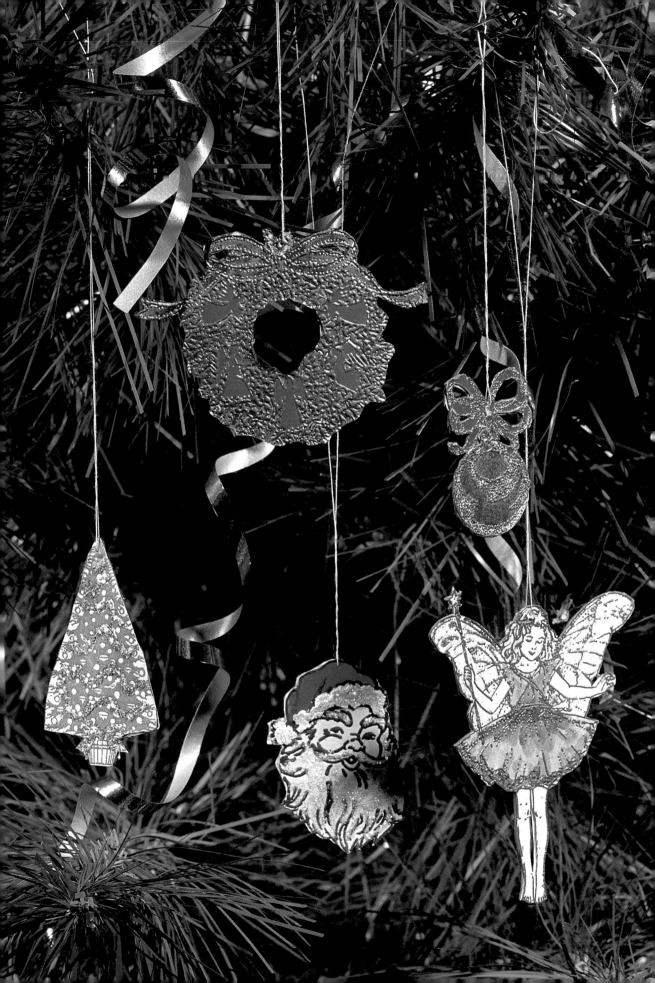

CHRISTMAS DECORATIONS

Designed by Lisa Hunter

'Tis the season to be very jolly when it is this easy to make bright, shining and unbreakable Christmas decorations for the tree and for other areas around the home. A collection of these cheery shapes would make a festive mobile to hang in doorways or above the fireplace.

MATERIALS NEEDED

for Decorations

- thin glossy white card
- pigment ink pads: black, green
- embossing powders: gold, clear
- heat gun, toaster or hotplate
- image reversal stamp
- assorted coloured markers
- glitter glue
- small scissors or craft knife
- needle and fine thread
- craft glue

Stamp each of the Christmas stamps on to the thin glossy white card using the pigment ink pads. Emboss each one and heat set (see the finished projects).

Using the image reversal stamp (see page 8), stamp a mirror image of the matching designs on to some more card. Emboss and heat set the designs.

An image reversal stamp makes it easy to create mirror images accurately.

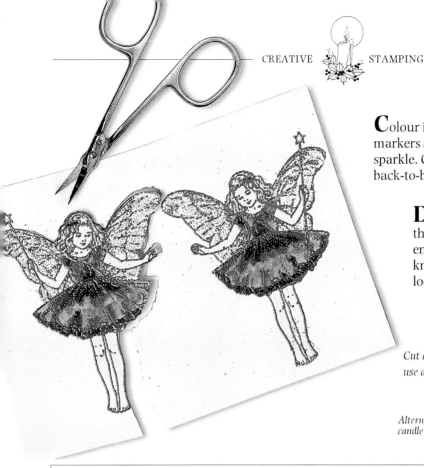

Colour in the designs with the coloured markers and highlight with the glitter for sparkle. Cut out the designs and glue them back-to-back.

Draw a threaded needle through the top of each decoration, leave enough thread for hanging, tie the knotted ends on each one to form a loop for hanging the decorations.

Cut carefully around the stamped designs and use a marker pen to touch up edges.

Alternative stamp designs: kitten in a sock, candle & holly.

THE STAMPS REDUCED IN SIZE

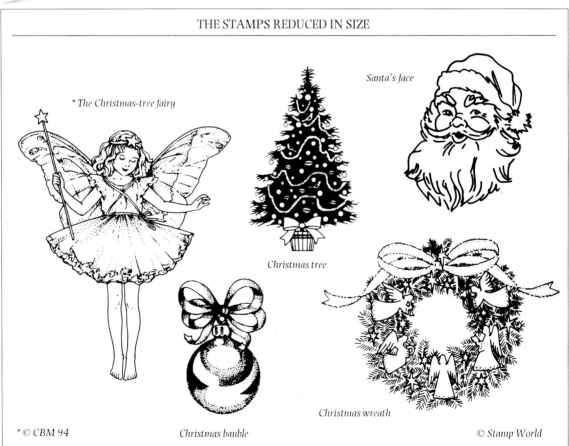

* The Christmas-tree fairy

Santa's face

Christmas tree

Christmas wreath

Christmas bauble

* © CBM 94

© Stamp World

WEDDING ACCESSORIES

Designed by Ellen Eadie

Weddings are a time of great joy for everyone involved. They symbolise all the potential that new beginnings offer. Every bride hopes that her wedding day will be a day of happiness and beauty. These elegant accessories will contribute an exquisite, personalised touch to that once-in-a-lifetime day.

MATERIALS NEEDED

for the Wedding Card

- *white card: 31.5 x 14.5cm (12$^{1}/_{8}$ x 5$^{3}/_{4}$in)*
- *pink card: 13.5 x 9.5cm (5$^{1}/_{4}$ x 3$^{5}/_{8}$in)*
- *green card: 14 x 10cm (5$^{1}/_{2}$ x 4in)*
- *ruler*
- *pencil*
- *craft knife and mat*
- *embossing ink: clear*
- *embossing powder: gold*
- *coloured markers: assorted colours*
- *double-sided foam mounting tape*
- *sheet of clear acetate*
- *iridescent hearts or confetti*
- *stamp positioner (optional)*
- *scissors*

Mark the white card into three equal sections, each 10.5 x 14.5cm (4$^{1}/_{8}$ x 5$^{3}/_{4}$in). Lightly score on the dividing lines using the pointed end of the scissors.

Cut a window approximately 6 x 8cm (3$^{1}/_{8}$ x 2$^{3}/_{8}$in) into the middle section of the card.

Stamp the wedding cake in position on the left-hand section so that it will be seen through the window when the left flap of the card is folded behind the window.

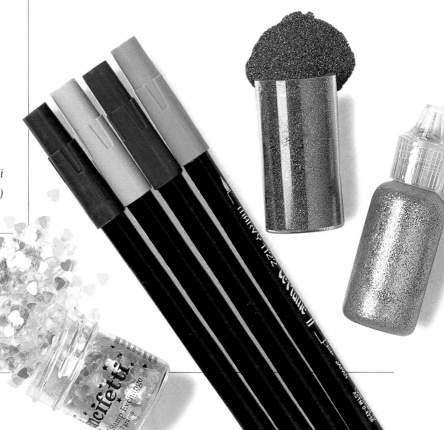

Sparkling hearts and other shapes add a glow to your handcrafted wedding accessories.

Sprinkle the image with the gold embossing powder, heat set and then colour in the cake with the markers. Stamp the wedding greeting on the inside of the last section of the card (the right-hand flap), apply embossing powder and heat set.

Cut a piece of clear acetate slightly larger than the window and, using the double-sided tape, attach it to the back of the card window. Again, using the double-sided tape, stick the middle and left-hand sections of the card together to form a frame for the window. Before sealing it, put some iridescent confetti into the window section.

Cut a window, 7 x 9cm (2⅞ x 3⅝in), in the green card and attach it centrally over the front of the white card window. Cut a same-size window in the pink card and attach centrally on the green card.

Stamp and emboss the rose border on the top and bottom of the pink card and colour in to complete.

MATERIALS NEEDED

for Wedding Frame
- *ruler*
- *pencil*
- *stamp positioner (optional)*
- *embossing ink: clear*
- *embossing powder: gold*
- *scrap paper*
- *coloured markers*
- *heat gun, toaster or hotplate*

Rule a line 1cm (⅜in) out from the inner edge (window) of the frame. Using this line as a guide (and a stamp positioner if available) stamp the floral corner with clear embossing ink and emboss it with gold powder. The words on the invitation will not be visible as they should be positioned over the window area of the frame. For safety, place a sheet of scrap paper where the words would fall. Emboss, heat set and colour in the design.

Use firm even pressure to ensure that each image appears fully on the first stamping.

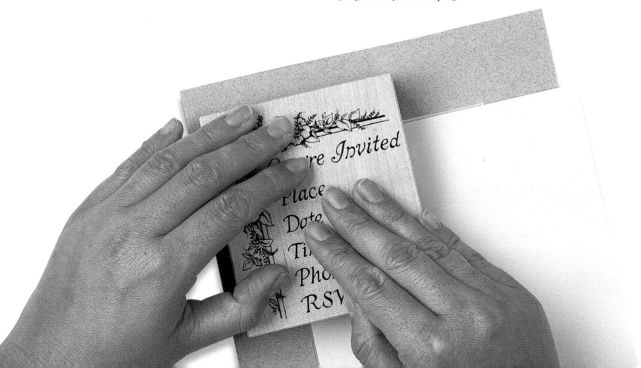

MATERIALS NEEDED

for Wedding Invitations

- *white card: 15.5 x 11.5cm*
 (6 x 4¹/₂in)
- *pink card: 16 x 12cm*
 (6¹/₄ x 4³/₄in)
- *green card: 16.5 x 12.5cm*
 (6¹/₂ x 5in)
- *clear embossing ink*
- *gold embossing powder*
- *assorted coloured markers*
- *embossing pen*
- *glue stick*
- *crystal and silver glitter glues*
- *heat gun, toaster or hotplate*
- *envelopes*

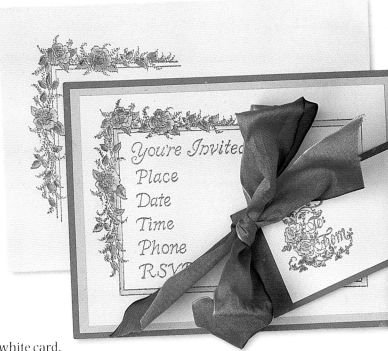

Stamp the floral invitation on to the white card, emboss, heat set and colour in. Draw a border around the outside with the embossing pen.

Embellish the design with crystal and silver glitter glues. Mount the white card on to the pink card and then on to the green card. The same stamp and technique can be used to decorate the envelopes with a matching look.

MATERIALS NEEDED

for Wedding Paper & Gift Tag

- *handmade paper*
- *plain gift tag*
- *clear embossing ink*
- *gold embossing powder*
- *assorted coloured markers*
- *silver glitter glue*

Stamp the handmade paper with the antique rose stamp, emboss and heat set. Colour in and embellish with the silver glitter glue. Make the gift tag in the same way, using the rose vine stamp.

Matching placecards and thankyou cards can be made using the same stamps, colours and trimmings. In this way you can build up a complete set of stationery for every aspect of a beautiful and unique wedding.

Alternative stamp designs: flower & basket, cherub with a bow, rose wreath.

You're Invited
Place
Date
Time
Phone
RSVP

Floral invitation

Antique rose

Wedding cake

Victorian rose border

Happy Wedding Day

Floral wreath

Rose vine gift tag

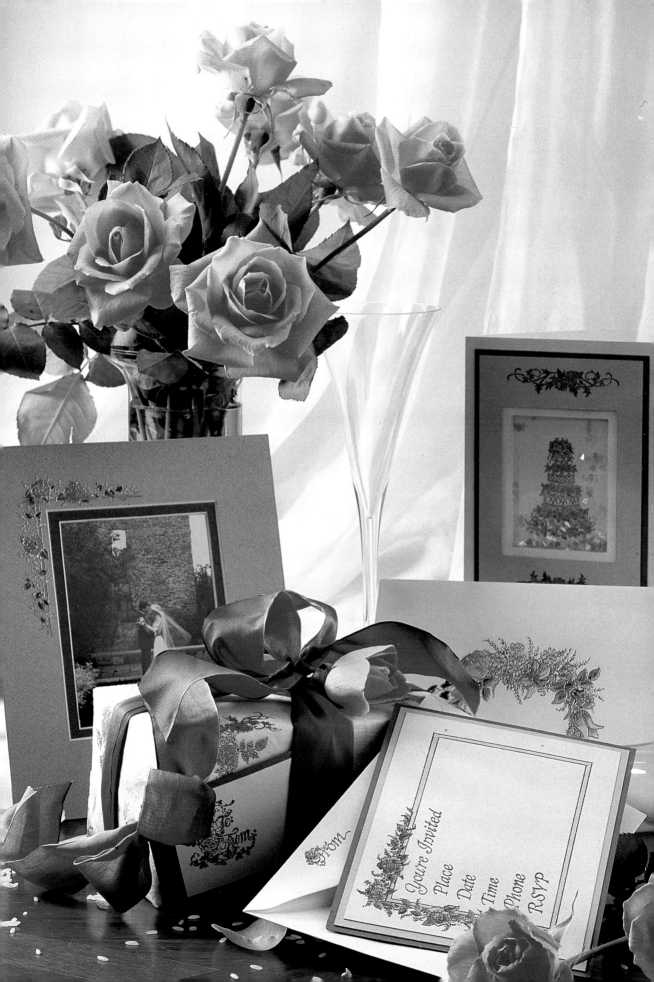

INDEX